KU-105-654

The

Photographer's
Guide to
Photoshop

0715 316346 5340 43

The
Photographer's
Guide to
Photoshop

BARRIE THOMAS

Girl.tif @ 100% (RGB)

Girl copy @ 200% (RGB)

Girl copy 2 @ 400% (RGB)

Girl copy 3 @ 800% (RGB)

Girl copy 4 @ 1600% (RGB)

David & Charles

For Austin and Charles
without whom it would not have happened.

WOLVERHAMPTON LIBRARIES	
0715316346534043	
H J	206481
770.28566 TH	£22.50
TR 9/04	JB

A DAVID & CHARLES BOOK

First published in the UK in 2004

Copyright © Barrie Thomas 2004

Distributed in North America
by F&W Publications, Inc.
4700 East Galbraith Road
Cincinnati, OH 45236
1-800-289-0963

Barrie Thomas has asserted his right to be identified as author of this work
in accordance with the Copyright, Designs and Patents Act, 1988.

All rights reserved. No part of this publication may be reproduced, stored
in a retrieval system, or transmitted, in any form or by any means,
electronic or mechanical, by photocopying, recording or otherwise, without
prior permission in writing from the publisher.

A catalogue record for this book is available from the British Library.

ISBN 0 7153 1634 6 hardback
ISBN 0 7153 1635 4 paperback (USA only)

Printed in China by Hong Kong Graphics and Printing Ltd.
for David & Charles
Brunel House Newton Abbot Devon

Commissioning Editor Neil Baber
Senior Editor Freya Dangerfield
Art Editor Ali Myer
Production Controller Kelly Smith

Visit our website at **www.davidandcharles.co.uk**

David & Charles books are available from all good bookshops; alternatively
you can contact our Orderline on (0)1626 334555 or write to us at
FREEPOST EX2 110, David & Charles Direct, Newton Abbot, TQ12 4ZZ
(no stamp required UK mainland).

CONTENTS

INTRODUCTION

With the power of Adobe Photoshop anything is possible – even the combination of graphics and photographs.

If it had been suggested over a decade ago, in the Stone Age of digital photography, that I would be writing a book even remotely connected with computers, I would have laughed out loud! In my mind it was already too late in life to consider these new fangled machines and in any case, we all knew that they blew up if you even touched the keyboard!

My interest was entirely photographic and, after navigating my way through the basic techniques, I found myself locked for long hours in a black box, full of unpleasant chemicals, trying to produce large multi-negative masks to use in the production of false-coloured photographs – lith masking – more akin to the world of Disney than pure photography. It was a crude and imprecise process, with many failures and uncertain results.

Whilst labouring to complete one of these masks, my son commented – as only your own children can – that I must be mad! The solution, according to him, was the use of a computer. With considerable reluctance I began to make enquiries and that was the start of it all.

The early years were a real struggle, pre-Photoshop: not a single understandable book on the subject was available; using primitive equipment; and with little or no basic knowledge. Very slowly it began to come together and it became clear that this was a much better way of working. Not too long after that it became abundantly evident that this was indeed to be the future of photography.

To say that it was a steep learning curve would be an understatement – it was a nightmare trying to come to terms with the basics of computers and digital imaging at one and the same time. What I did not realize then was that the impossibility of this situation was to enable me to be of great assistance to those who later took up this challenge. My need to understand even the most basic processes before I was able to move on had equipped me, perhaps better than most, to answer the many questions asked on the road to understanding the complexities of the program and the process.

For years I resisted requests to write a book on the subject. Firstly, the bookshelves were already collapsing under the weight of expensive Photoshop volumes, many of them with insufficient information and poor photographs, and secondly I could not imagine how Photoshop could ever be adequately covered in print. Now that I have completed the task, I have to admit to being satisfied with the result. Anyone, no matter how new to imaging, should be able to emerge from the experience with a reasonably comprehensive understanding of this wondrous new world and go on to experience the creative opportunities to the full.

The screen images throughout the book were prepared on a PC, but if you are a Mac user don't worry as the screens are virtually identical. Keyboard shortcuts are sometimes different – the main ones are mentioned in the text and other important ones are listed on page 142.

This book does not aim to cover every nut and bolt of the program, that would simply duplicate the manual like many books before; instead it reveals and expands those elements that are essential to most users, especially photographers, and makes them understandable. Enjoy!

THE BASICS

The digital image

There are two fundamental ways of working in Photoshop: with **bitmaps** or **vectors**. Most work associated with digital photography is done using bitmaps.

BITMAPS

Imagine sitting in a helicopter about to take-off from a mosaic pavement; as you awaited take-off you would see lots of tiny coloured squares, but as you moved upwards they would combine to form a picture, and the joins between them would no longer be apparent. This is the principle of a bitmap, which is simply a collection of tiny dots of colour, packed so tightly together that you cannot see the joins.

So what exactly are these coloured dots, and how are they formed? To find the answer you need to delve into the workings of a computer. We attribute all sorts of wonders to our computers, but in reality they are simply a collection of high-speed switches. Computers do not understand photographs or the Internet or anything else; they need software to interpret the data for them.

SIMPLE COMPUTERS!

Think of a single light switch: it can only be in one of two conditions, on or off. If you were to add tones to this you could set it to be white when switched on and black when off. There are no other options.

What happens if you add a second light switch? Now you have four possibilities: both switches off, both on, or switched in either direction; if you now add your tones you could display black, white and two shades of grey. Carry this idea further to eight switches, and there are 256 variations and therefore 256 possible shades of grey.

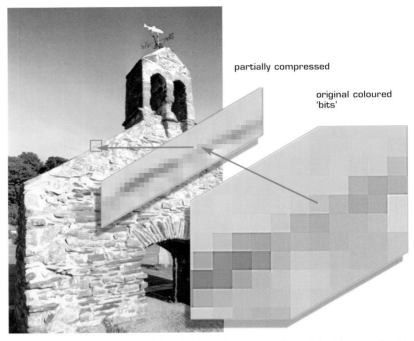

partially compressed

original coloured 'bits'

Magnifying a tiny part of the original image clearly shows the 'block' construction.

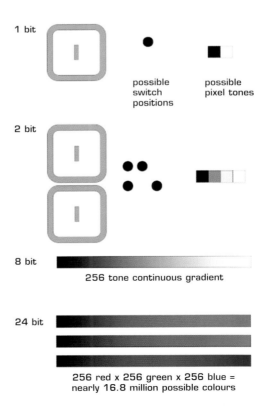

1 bit

possible switch positions

possible pixel tones

2 bit

8 bit

256 tone continuous gradient

24 bit

256 red x 256 green x 256 blue = nearly 16.8 million possible colours

Using more switches allows a larger number of colours to be determined, since there are many more variations of switch position.

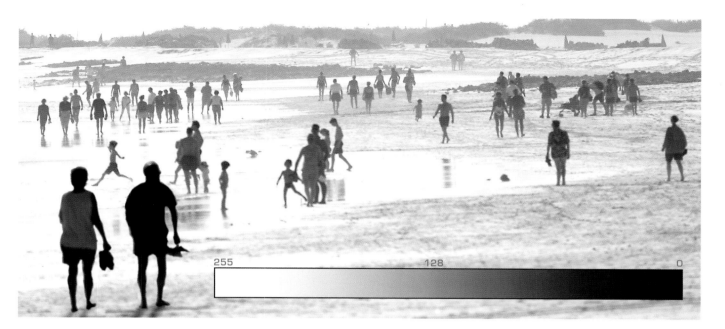

255 128 0

At this stage it becomes interesting because the human eye cannot differentiate 256 shades of grey, which merge into each other and appear as a continuous gradient from black to white. This is referred to as 8-bit colour, each bit being equivalent to one of the switches.

The eight bits of information that are needed to determine a particular shade of grey are sent to the computer as a series of eight numbers: 00000001 represents the number 1, while 00000010 represents the number 2, and this continues throughout the possible switch positions up to 256. This grouping of eight bits of information is known as a byte, the familiar term used to identify file sizes and hard disks etc., usually recorded as Megabytes or millions of bytes.

This 8-bit image, made up of 256 shades of grey, appears to show a continuous gradation of tone to the human eye.

COLOUR-BLINDNESS

At the bottom of the 'switch' diagram shown opposite it suddenly leaps from 8-bit greyscale to 24-bit colour; this does not mean that you now need even more switches to define each colour, but simply that you need a way of adding colour to the basic 8-bit greyscale, and this is the job of the monitor. If you add red, green and blue to three different greyscales you would then have a full range of each of the three colours that our eyes are able to identify. This is now 24-bit colour and is usually referred to as true colour, since it allows well over 16,000,000 colours to be displayed, which is more than the human eye can differentiate.

It is worth bearing in mind when working with digital images that the computer is actually colour-blind. Computers work in black and white, and the colour is added by the graphics card and monitor.

The monitor diagram on the right illustrates how this is possible: each byte, containing the eight bits of digital data that identify its specific tone, is fed to the graphics card in your computer.

Monitors display analog information, so on your graphics card there are DACs – digital-to-analog converters – that convert the bytes of information into tiny voltages, which are then fed to the monitor. Here they activate the electron guns, with the appropriate level of brightness for that colour, before firing a fine electronic beam at the monitor screen.

You now have the right light value for your on-screen dot, and all that remains is to focus it accurately. Once focused it hits the back of the monitor screen and 'glows' on the phosphor lining, to display the precise colour for that dot.

The result of all this, as far as the Photoshop user is concerned, is a tiny square of colour on the screen known as a **pixel**, a **Pi**cture **El**ement. Pixels are the basic building blocks, the atoms, of any bitmap image. They are all the same shape and size, and it is worth bearing in mind that any individual pixel can only contain ONE colour. Whatever the colour, it is defined by just three values, for red, blue and green, each with a numeric value somewhere between 0, which is black, through to 255, the brightest colour possible.

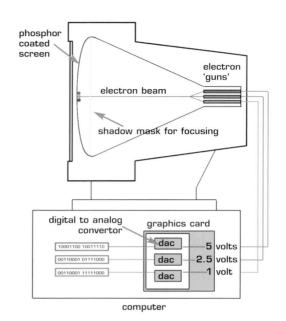

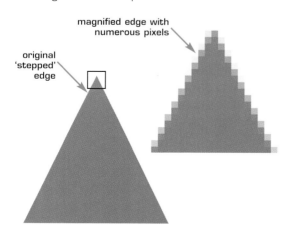

This bitmap triangle is made up of thousands of tiny 'bits' of data. The minute blocks can just be seen on the edge of the original, but become very obvious when the shape is magnified.

Digital data is converted to analog voltages by the graphics card before being passed to the monitor and displayed on the screen.

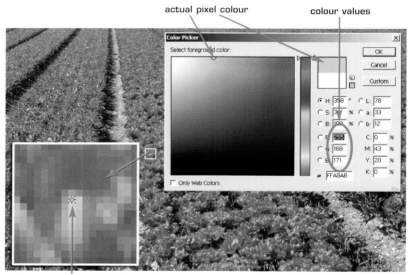

The red, green and blue values for the pixel selected are simply numbers between 0 and 255. The computer can identify the colour required on-screen from this information.

VECTORS

Suppose you wanted to draw a bitmap triangle and then paint it red. It would be unnecessarily large because it would still need to have many pixels in it, even though they were all the same colour. It is not possible to have larger or smaller pixels!

The edges of the triangle would also be 'stepped' because pixels are square, and if you decided to make it bigger after first constructing it, the edges would look awful.

It's clear then that bitmaps are ideal for photographs, but less efficient for graphics. The solution to both these problems is to use vectors, which take a different approach to the problem altogether.

If I wanted to instruct a computer to draw a red triangle, instead of playing with tiny squares of colour I could draw a line at 45° from vertical 2cm long, then from the end point draw a line at 135° from vertical 2cm long and join the new end point to the first. Now I could fill the whole area with red.

This is of course very basic geometry, and to computers anything involving maths is ridiculously simple, since that is how they work. The example above has the added advantage that if you then give an instruction to make the triangle bigger, it recalculates and redraws it perfectly.

Vectors then are ideal for anything that involves straight lines and curves. It doesn't matter how complex the curves are, and shapes that would seem impossible are just broken down by the computer into easily managed segments. Text is a good example of this, since it would appear impossible to draw the letters, but once the computer has the necessary information, text can be drawn and resized as vectors without any loss of quality at all. Other examples of vectors that will be examined later are Photoshop's Shape and Pen tools.

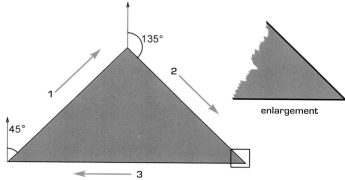

A vector triangle is just a set of geometrical instructions, filled with colour. Increasing its size does no damage to the edges.

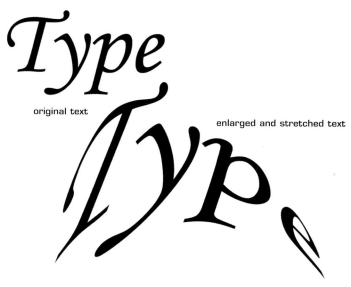

original text

enlarged and stretched text

Vector type can be resized and reshaped wildly without any loss of quality.

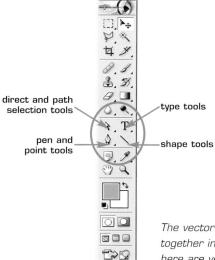

direct and path selection tools

type tools

pen and point tools

shape tools

The vector tools in the toolbox are grouped together in one area, but not all of the tools here are vector-based.

Bitmaps are sometimes referred to simply as images, or even as painting; vectors are known as graphics, or drawing. The two systems do not co-exist well – in Photoshop they are like oil and water and do not mix. To allow you to use both methods when working on an image, Adobe has arranged the program so that vectors and bitmaps work separately on different layers within the image. If you ultimately flatten the image to get rid of these layers, any vectors are rasterized, a process that converts the lines and curves into a bitmap.

Acquiring images

GETTING IMAGES INTO THE COMPUTER

Most of the earlier methods of placing images onto a computer involved some form of scanning, to convert the analog information of the photo into digital data for the computer; this all changed with the advent of digital cameras that capture the original information directly as digital data.

The developments have been remarkably rapid; just over a decade ago Kodak produced a system that made it possible for those unable to scan their own images to get good-quality scans made for them at reasonable prices onto Kodak Photo CD, via their local shop. This system was in no small part responsible for me and many others entering the digital arena, and for the rapid growth of interest in programs such as Adobe Photoshop. Photo CD is no longer available, and I suspect this is in no small part due to similar quality scans now being obtainable at home from inexpensive scanners.

Kodak Photo CD was the first affordable way for the general public to have photos digitized for home manipulation.

SCANNERS

The scanning process is all about getting digital data into your computer. Basically, the more pixels you can acquire the better, but the quality of that data must also be considered because not all scanners are equal.

1600%

600%

percentage view on screen

magnified view on screen

original photo

600dpi scan

1600dpi scan

This image was scanned at 600dpi, and again at 1600dpi, therefore there are many more pixels in the image. In a compressed screen view it cannot be seen, but when enlarged the smaller image quickly degrades. This would be obvious in a large print.

Scanner quality is best tested by trying one out before parting with any money, but there are a few points to bear in mind:

- The higher the optical resolution (dpi) the more data the scanner will collect from a given area. Make sure it is the optical resolution that you consider, not some interpolated figure.
- Higher bit-depths denote the ability of the scanner to critically differentiate between tones in the image. Higher numbers give better differentiation.
- Density is also important, and again higher numbers are better. Be aware that these are low values, from 0 to 4.

There are many types of scanner, but the only two that need concern us here are flatbed and film scanners; both of these are readily available through computer and photographic outlets, at a wide range of prices to fit most pockets.

Flatbeds These are the cheapest scanners and started life as fairly crude devices, little better than photocopiers; they have improved massively in recent years. They are best used for non-reflective print scanning, but many now provide a transparency hood (light source) to also allow film to be scanned. Typical flatbed scanners have an optical resolution of 1200–2400dpi, but this figure is steadily being pushed upwards. Density is rarely much more than 3, although the better ones exceed that. Expensive professional models are not considered here.

Film scanners These are more specialized devices, and because they are dedicated to just one task, that of scanning small-format film, they are normally of a much higher specification and ability than flatbeds. Film scanners become very expensive as the area they scan increases beyond the common 35mm format. The optical dpi is typically 2700 to over 5000dpi with high density figures, perfectly capable of handling all the usual film materials.

Epson Perfection 2450 photo flatbed scanner with built-in transparency hood with 2400dpi optical resolution

High-resolution flatbed and film scanners are suitable for home and office use.

Nikon Super Coolscan 4000 film scanner with 4000dpi optical resolution

A tiny part of the original 35mm image opposite, scanned at 4000dpi and shown at full scale from the resulting file.

WHICH TO CHOOSE?

That's the difficult one, and it really all depends on where you want your images to end up.

Web If the output is only for email or for use on a website, it needs very little data to produce a good image on screen. In this case, the least expensive flatbed scanners should suffice.

Print If prints are required, the size of the finished print is a major consideration. Large prints need lots of pixels if you are to avoid interpolation of the image and the possibility of pixels being seen in the final print; typically you need around 6Mb for a 15 x 10cm (6 x 4in) coloured image, and as much as 25Mb for A4 size 29.7 x 21cm (11$^3/_4$ x 8$^1/_4$in). Make sure the scanner is capable of this before parting with your money.

The other side of this coin is the starting point, and getting 25Mb of good data from a small 35mm negative is much more difficult than getting it from an A4 print; in other words, it needs much more magnification to achieve the same result. The best advice is to scan from small film originals with a dedicated film scanner and from larger originals, film or print, on a good-quality flatbed. Either way, buy the best that you can afford.

Many photo outlets provide scanning services, so if you have the occasional 'odd' size, or if you decide not to buy a scanner at all, you can get someone else to do the scanning for you.

THE BASICS **2** ACQUIRING IMAGES

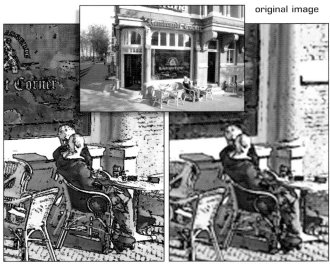

original image

from 4mb file from 0.25mb file

The print from the smaller file on the right is inferior to the image on the left, which uses 16 times more data. Both versions looked similar when viewed on-screen.

DIGITAL CAMERAS

Although you need scanners for photos already in your possession, you may well not need them in the future – not if you have a digital camera, that is!

Digital cameras are arguably the best way to get your photos digitized because this is done as the photo is taken; the 'rules' about quality and quantity of pixels do not change, however. The cost of digital cameras reflects this, and those with high pixel counts, usually marked on the front of the camera, will normally be more expensive. Bear in mind that the number quoted is for a black-and-white image, and therefore only a third the size of a colour image containing three channels: a 3-megapixel camera produces a coloured image of around 9Mb in size.

Once you have decided how many pixels you want to pay for, then it comes down to the quality and facilities of the camera itself. The range of digital cameras varies from simple point-and-shoot compact ones to sophisticated single lens reflex (SLR) camera systems that take interchangeable lenses and all the accessories that go with SLR. The cost varies accordingly. Buy the camera with the highest pixel count you can afford, but read the reviews in photographic magazines first and don't necessarily buy the latest model, as it will always be much more expensive than its predecessor!

Don't be tempted to shoot low-resolution images to save space on the card; remember, you need lots of pixels. If you want good results shoot at the highest JPG quality, and if necessary buy more storage cards to be able to continue shooting. Here, the exception may be when shooting small images for on-line use, when a simple 1.2-megapixel camera with a good lens would suffice.

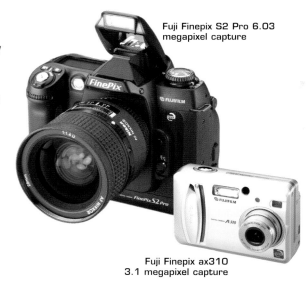

Fuji Finepix S2 Pro 6.03 megapixel capture

Fuji Finepix ax310 3.1 megapixel capture

The larger digital camera is based on SLR technology, with interchangeable lenses and many accessories; the smaller one is a simple point-and-shoot model.

OPENING IMAGES

Finally, you need to consider how to actually get the photos into Photoshop. Most good-quality scanners use the Twain interface, an industry standard that is built into Photoshop. Your scanner is accessed from the 'Import' command in Photoshop and this opens the software. Read the instructions for your scanner and the accompanying software very carefully, because this is another skill that must be learned. If the picture is scanned badly, any data lost from the original cannot be reclaimed from within Photoshop.

Scanning facilities for the Nikon Super Coolscan 4000, provided from within Photoshop.

If you are using a digital camera the manufacturer will provide the necessary leads and software to get the images downloaded, but this can be a slow process. A faster and arguably better way to download is via a dedicated card reader, into which the storage device is placed, and then the images are accessed directly from it.

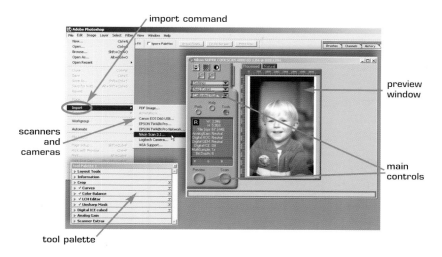

import command
preview window
main controls
scanners and cameras
tool palette

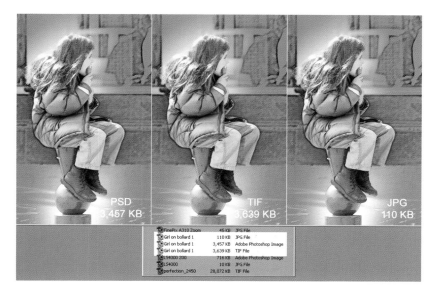

These images were saved in different formats from the same original; the compressed JPG file is much smaller. No real difference is apparent on-screen, but the JPG file would be inferior when printed.

SAVING IMAGES

When you have the images in Photoshop and wish to save them, do not just click 'Save'. If you do, the image will be saved again to JPG and further compressed and degraded. If saved as a Photoshop (PSD) or Tiff (TIF) image, no damage will be done to it at all.

There is much misunderstanding about these file formats – basically they are different ways of packaging the data, and your program must understand the format to be able to unpack it. There are really only three that need concern photographers:

PSD files are Photoshop's own native file format, and are foolproof. When working in Photoshop, save your images as PSD files and you cannot go wrong, as this is the only file format that 'understands' everything that Photoshop does.

TIF is the universal standard for image storage and can be accessed by any computer program designed to display images. If you want to save images to take off your computer and send to someone else, but you don't know whether they have and use Photoshop, play it safe and send them as TIF files.

JPG files are compressed files and therefore much smaller in size; because of this, JPG is the format of choice for photos to be used on the Web.

Managing images

SAVING FILES

A photograph is no different to any other digital file; it's just a collection of bits of data that is reconstructed by the computer to form an image. This data is altered when you work on the image and therefore needs to be saved in some way if you want to retain it for future use.

When saving in Photoshop, make sure that the photo is active by clicking on it, then click on the File menu and choose Save from the drop-down list. Go carefully here because the original photograph will be totally erased and replaced by the altered one when you click the Save button. If you want to retain the original image as well as the modified one, choose Save As; this will leave the original photo unaltered, but save a new version as it now looks on-screen. If you have made changes and decide to save the image as another photo on the hard drive, make sure that it is given a changed title or you may destroy the original image.

A working practice that I employ is to open an image and after working on it for a while resave using Save As. The file name is retained, but the successive saves are given numbers so that I always know the sequence. The big advantage of this is that if I make an irrecoverable mistake or the computer crashes, I can always get back to a recently saved image. More experienced users may be thinking that in these days of History palettes this is unnecessary, but it has frequently got me out of trouble, and in any case the unneeded versions are discarded when the image is completed.

When you save your photo what you are really saving is the data, which has to be stored somewhere until needed again. The main storage area is usually the hard drive inside your computer, which is able to store vast amounts of information.

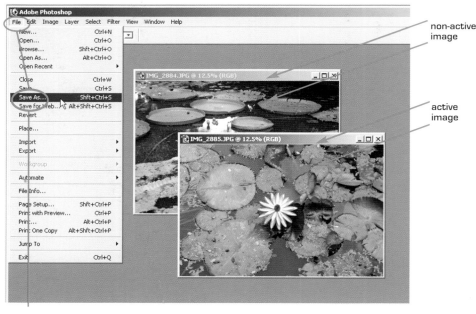

non-active image

active image

save as command

The active image has a coloured title bar and is always the one on top.

CREATING A FILE STRUCTURE

When you click Save As the box that appears will open up at a folder you used recently; if you then click Save the active image will be placed within it and disappear into the computer's filing system and you will have no idea where it is within the computer when you need it next. Creating a set of folders to store photos can be done from within Photoshop.

After clicking on Save As to gain access to the file structure, clicking the small arrow alongside the top box marked Save in reveals the layout of your entire computer; it is here that you choose the drive you wish to use. Click onto that drive and click Open, or just double-click the drive name and its title will appear at the top, with a list of its contents below.

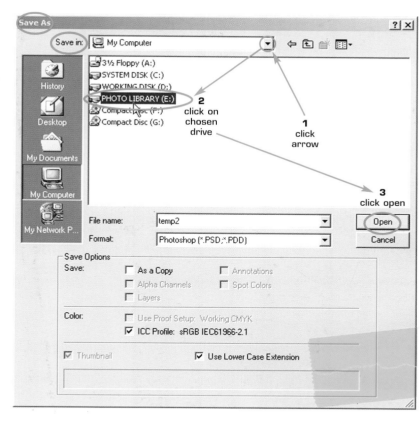

When 'Save in' contains 'My Computer' the major components of your computer are displayed. Here, there are three hard disk drives that have each been given a name.

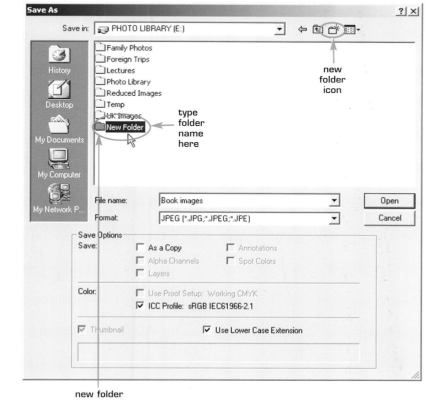

new folder

Now you are looking at the contents of that disk, and can create your own folders in here to hold whatever you want. Click the icon at the top right, showing a folder with a glint attached to it, and a new folder will appear, already highlighted and ready for you to insert its name. Type in the title and then just click away from the name, and there you have it – a brand new folder ready to hold your photographs.

This process can be repeated as often as you like, and it is a good idea to sit down at an early stage and determine the entire folder structure you require.

This drive already has several individually named folders for image storage, making images very easy to find.

PLACING AND NAMING YOUR PHOTOS

Having created the filing system, it is important to use it. As before, click Save As and then click the arrow to gain access to the file structure. This time instead of just clicking the Save button, move through the folders, double-clicking the folder names to open them, until you see in the top Save in box the name of the folder where you want the images placed. When you next want the picture, you know exactly where to find it.

A succession of double-clicks reveals each folder's contents in turn until the one required is reached.

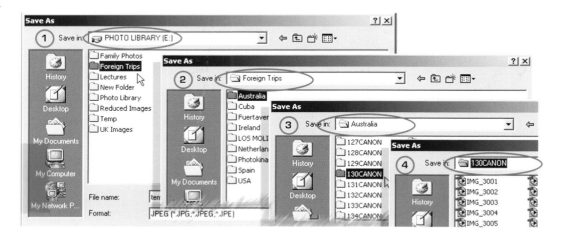

Before clicking Save there are two other tasks: you must name the image and also tell the computer how you want the data 'packaged'. The name can be anything you choose, as long as it does not already exist within that folder.

The choice of file format determines how the image data is packaged and therefore which programs will be able to open it later. Clicking on the arrow alongside Format accesses a full list of the options available. For simplicity, use one of just three formats, which is all you need for photographs:

.PSD if the images are to be used within Photoshop.

.TIF if the images are to be sent elsewhere on a disk.

.JPG if the images are to be sent via a modem or used on the Web.

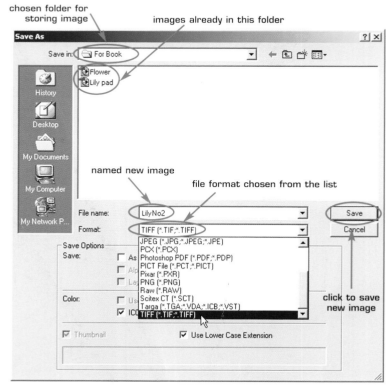

chosen folder for storing image

images already in this folder

named new image

file format chosen from the list

click to save new image

Files must be named and a file format allocated before they are saved.

This is a composite image of file format choices; scrolling is normally required to see all of the alternatives.

dvd writer

cd/dvd player

The external appearance of CD and DVD writers is very similar – ensure that you get the right type installed.

BACKUP AND REMOVABLE STORAGE

Saving your images to the hard drive is vital and should be done frequently, but if the file is really important to you, it should also be backed up off the computer. There are a number of external storage devices but there are only two worth considering seriously, CD and DVD writers.

Virtually every computer has a CD installed for reading disks, but if you want to save your own images onto a blank CD disk you will need a CD writer. This is referred to as 'burning' a disk and requires a separate program that comes with the writer.

CDs vary a little in storage capacity, but most store a minimum of 650Mb of data. There are two different types: they may either be written or burned once, which means that you can place data onto them once only, or rewritable, where it is possible to reuse the disk by erasing some or all of the information previously recorded. Write-once is safer and reduces the risk of deleting files that you may later need.

DVD is a similar technology that looks identical but allows the use of several layers within the disk and therefore increases the storage capacity enormously: storage capacities of 4.5Gb, 9Gb and more are not unusual. Although more expensive, DVDs have to be the storage device of choice, since the players are also able to read CDs. DVDs are likely to replace CD as the industry standard storage device since they fit into a standard CD-sized bay and are a great deal more efficient.

THE HARD DRIVE

The hard drive is a box normally housed unseen within your computer case. It is a mechanical device containing a revolving platter and writes the image data onto the disk surface. When a file is needed, the data is read from the platter back into the computer and reappears unaltered on the monitor screen.

Hard-disk storage is cheap in terms of how many megabytes you get for your money, and it is also the quickest and most convenient form of storage. Images are large and require lots of storage space, so it is a good idea to have large hard drives fitted to your computer – over 20Gb is advisable.

If your existing hard drive is getting congested, don't panic; you can always get another drive fitted. This is an easy and very satisfactory way to increase your storage, and has the added advantage of allowing all the files created by you, including your images, to be placed onto one drive and all the system and program files to remain on the other drive. With all your data in one place, it is easy to back it up regularly.

Seagate Barracuda hard disk

This view shows the revolving platter and head reader arm on a hard disk.

Sizing images

FILE SIZE

The size of a digital image is usually expressed as the number of pixels the file contains, and because images usually contain lots of data, this would normally be seen as a value in **megabytes (Mb)**, or millions of bytes. It may come as a surprise to find that 'mega' in computer jargon is not the conventional 1,000,000 but a rather strange higher figure of 1,048,576.

Without going into long explanations, it is sufficient to say that to make use of the 'switches' within a computer system, everything in computer terminology is based on the binary system, which uses 2 and not 10 as its basis. This explains why virtually all numbers for hard drives, RAM (random access memory), camera storage cards etc. are measured in multiples of 2: 4, 8, 16, 32, 64, 128, 256, 512, and 1024.

There are 1024 bytes in a **kilobyte (Kb)** – or 2^{10} bytes for those wanting to understand the maths – and therefore a 1Mb image contains 1024 x 1024 bytes or approximately one million bytes of data. In the Photoshop Resize box, which is opened by clicking on Image and Image Size, instead of using bytes, the data is referred to as pixels.

If you try this for yourself, do not be surprised if the pixel dimensions show the image as 3Mb instead of 1Mb! The calculation above is true for a monochrome image with only one channel, but coloured images normally have three channels, one each for red, green and blue. Since each of these three channels contains the same number of pixels, the actual file size is three times greater.

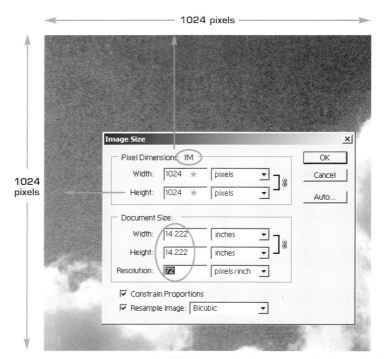

A 1Mb image that is composed of grey pixels, and therefore does not have any coloured channels, contains just over a million pixels.

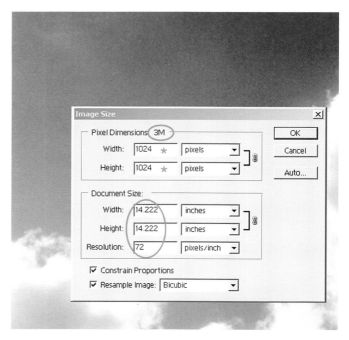

This coloured image is the same size as the one above, but contains more pixels because of the three coloured channels.

RESOLUTION

All these pixel values are meaningless unless the computer, printer or whatever is told what to do with them. Suppose I gave you a hundred tennis balls and told you to arrange them on the floor – after questioning my sanity, you might well ask how I wanted them placed. 'How far apart?' is a necessary piece of information to be able to complete the task, and computers require similar input.

In the Image Size boxes opposite you can see that the total number of pixels is roughly one million, but the size of image that results from placing all these dots on-screen, or printing them onto a piece of paper, is governed by how closely together the dots are packed; this is known as Resolution and is normally measured in **dots per inch** or **dpi**.

Both Image Size boxes at below right show 1024 x 1024 pixels as the dimensions of the image. The information has remained unchanged because the Resample Image box has been unchecked and therefore you can resize freely without adding any additional pixels to our image; in fact, when you remove the tick from here the Pixel Dimensions area turns grey and is therefore unusable.

Now look at the Document Size portion and you will see why resolution is so important. In the upper example at 64 pixels/inch (dpi) the resulting picture from 1Mb of data is 4.5cm (16in) square, but in the lower one, which has a higher pixel density, it is only 10cm (4in) square.

Although this can cause considerable confusion, it's not really complex at all. What we have here is a simple division sum: if you divide 1024 by 64 the answer is 16, whereas if you divide the same number by 256 the answer is 4. Another way to view it is that if you were to pack 256 pixels along the first 2.5cm (1in) of the paper, and then another 256 in the second 2.5cm (1in) and so on, by the time you reached 1024 the image would be exactly 10cm (4in) wide and you would have used up all of the available pixels. This would appear to indicate that the image can be reproduced to virtually any size by inserting a lower resolution value, but of course there is a price to pay for that.

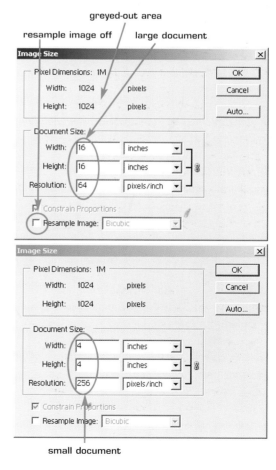

If the Resolution is changed with Resample Image unchecked, this has the effect of resizing the entire image.

BEST RESOLUTION VALUES

It is possible to indicate the best resolution value in terms of dpi, as long as you know what the image is going to be used for. It would be nonsensical to send an image of many megabytes across the Web for on-screen viewing, and equally silly to try to print a large image from a very small file size.

On-screen images

Computer screens are only capable of displaying a limited number of dots on-screen; this is known as screen resolution and is normally 72dpi on Apple Mac machines and 96dpi on PCs. There is little point in exceeding these numbers for viewing on a conventional monitor, since the quality of the image will not improve, whether you are viewing it on your own screen or sending it to someone else via the Internet. If you carry this one stage further, it becomes a question of how large you want the image to appear on-screen. This can be determined using File > New and inserting the values required.

Let's assume that you want a good-quality image at an on-screen size of 20 x 15cm (8 x 6in). Insert the figures into the width and height boxes and then put in your screen resolution, in this case 72 or 96dpi. The result is seen as a required file size for a coloured image of just 1.23Mb, which is the amount of original data required, easily obtained with a basic digital camera.

Printed images

Printing requirements are quite different to on-screen viewing; here, you want to pack the pixels closely together, so that ideally they cannot be seen at all in the finished image. Many people complain about the quality of their prints or printers, yet all too frequently much of the damage is caused through using an incorrect resolution or haphazard resizing.

If a low resolution is set for a given amount of data the image will be large, but if it results in the dots being too widely spread out on the finished print it will look awful. The lowest value that can be acceptable here is around 150 pixels per 2.5cm (1in), on the assumption that if it is a larger image, you will view it from further away. Fine prints require a much closer spacing, and somewhere between 240dpi and 300dpi is perfect.

Do not be tempted to go higher than this; it is unlikely to harm your image, but it will certainly not improve it, because at 300dpi and above the dots all merge together as far as the human eye can see. The worst scenario is to place in the box the figures associated with the resolution of your printer, typically 1440 or 2880; these figures refer to the distribution of the dots of ink on the paper and have very little to do with the actual number of pixels in the image and their distribution.

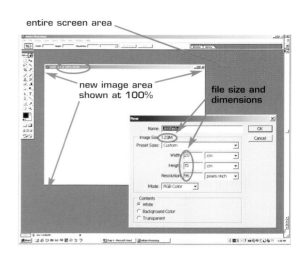

It is not necessary to have large file sizes to be able to display your images on-screen at a reasonable viewing size; this one, shown relative to the monitor screen, is just 1.23Mb.

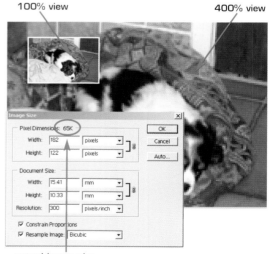

This original image was only 65Kb, and although small enough to travel over the Internet quickly, it is useless for printing. At the 'correct' viewing size of 100% it is small; viewing at a larger scale makes it pixellated.

In many cases you do not know the ultimate purpose to which an image will be put, and it is a good idea to collect and save it with lots of original high-quality data – lots of pixels – in case you need to print from it.

CONSTRAIN AND RESAMPLE

At the base of the Image Size box are two tick boxes. Constrain Proportions ensures that when you resize an image it does not become distorted. If the width is changed the height will reflect the same proportional increase, and vice versa. If Constrain Proportions is switched off, the link icons locking them together are removed and images can be distorted to any shape or size, by changing either one of the values for height or width.

Resample Image allows the values to be changed in any of the boxes, and as a result the whole image will be resized and reshaped. This can be dangerous because indiscriminate changes here can result in new pixels, which were never in the original, being added to the image. The process is known as Interpolation, and the computer makes its 'best guess' for the new pixels to be added, based upon the colours of those surrounding it. How carefully it does this is governed by the box alongside; for photographic work this is best left on the most accurate setting of Bicubic.

Switching Resample Image off stops the actual pixel dimensions from changing, and therefore stops the picture being 'damaged' by being resized. It becomes, in effect, an instruction to the printer as to how to apply the dots to the paper without using any Interpolation.

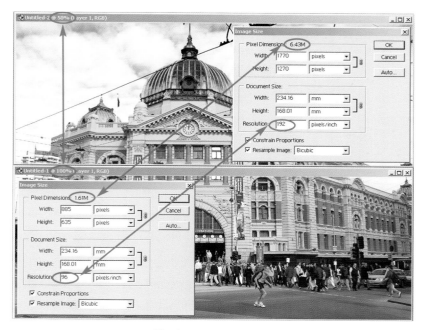

The lower image is only 1.61Mb at screen-resolution and appears like this at 100% magnification. The upper image is four times larger, and yet looks identical on screen because it is only being viewed at 50% magnification.

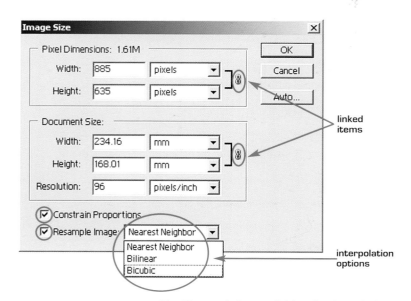

The Resample Image tick box is of particular importance; used incorrectly, it can add pixels to your image that were never in the original photo.

The workspace

FINDING YOUR WAY AROUND THE PHOTOSHOP DESKTOP EFFICIENTLY CAN SAVE MUCH TIME AND FRUSTRATION LATER. WE SHALL GO ON TO LOOK AT MANY OF THE ITEMS IN MORE DETAIL, BUT THIS CHAPTER PROVIDES AN OVERVIEW OF THE WORKING PROCESS.

SCREEN SETTINGS

Monitor set-up is of tremendous importance, and it is vital if you are working with Photoshop that you use 24-bit colour, or higher. Use a large monitor and make sure that the screen area is at least 1024 x 768. Larger working areas are better, enabling you to display images unobscured by palettes, but some people find very large resolutions uncomfortable to work with; choose the largest setting that you can read easily.

To access the Display Properties dialogue box, click the Start button and then click Settings and Control Panel; click on Display. This opens the Display Properties, and both Colors and Screen area controls are found under the Settings tab.

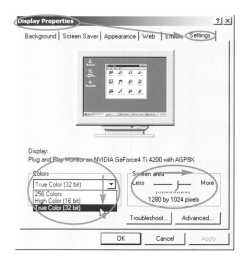

This allows the screen area and colour bit depth to be adjusted in Windows.

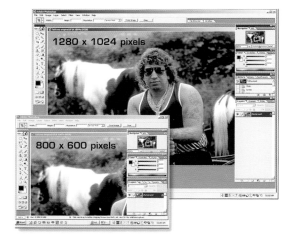

Screen areas set with high resolutions allow much more of the image to be seen on-screen. In the example above, the higher resolution displays an area almost three times larger than the one below.

DESKTOP LAYOUT

When Photoshop is first installed all the Palettes are open and arranged to the right side of the screen, with the toolbox on the left. If they must be left open this is as good a position as any, but it makes much more sense to try and optimize the working space before opening any images.

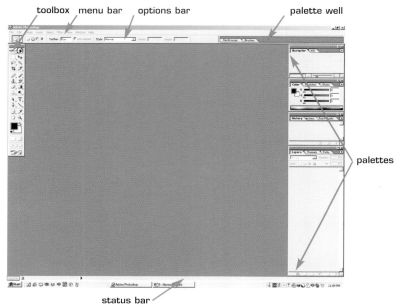

The default desktop in Photoshop is arranged like this, but it is much better to customize it for your own use.

TOOLBOX

At first glance the toolbox appears to have just over 20 items in it, but there are many more hidden away. Clicking on any one of the visible tools makes it active, but clicking and holding the mouse over any of the tools with black triangles in the corner reveals other choices. Move the cursor over the one you require and then release the mouse button to select it.

The toolbox is divided into sections, broadly grouping those items that have a similar purpose. The lower divisions are arguably not tools at all but relate to colour, masking, viewing and even another program, but it is convenient for them to be readily accessible here. The toolbox is in constant use and is normally left on screen, but if it gets in your way press the Tab key on the keyboard and it will disappear; press Tab again and it returns. This is a very useful device to enable you to view your images without surrounding clutter.

The tools can also be accessed directly from the keyboard using shortcuts, and these can greatly speed up the work process. Ultimately, it is necessary to learn the correct keystrokes, but to help you they are marked alongside the hidden toolbox items, as well as on the tool tips that appear if you hold the mouse over a tool but do not click.

OPTIONS BAR

The toolbox is very closely allied to the options bar, since one depends upon the other. Both devices are normally on-screen at all times, but if for any reason you cannot see the options bar, go to the Window menu on the menu bar and click Options to activate it. If you click on a few tools while watching the options bar, it will quickly become apparent how it all works. The options will change with each tool selected, extending the working possibilities for that tool.

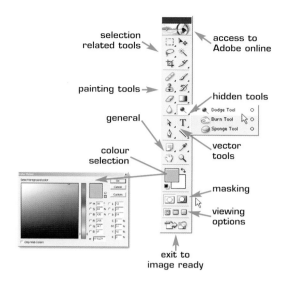

The divisions of the toolbox are not specific, but they show a broad grouping of those tools that behave in a similar way.

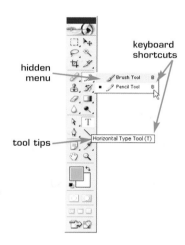

The letters alongside the tool names and those that accompany the tool tips are shortcut keys. Pressing the appropriate letter on the keyboard directly activates that tool.

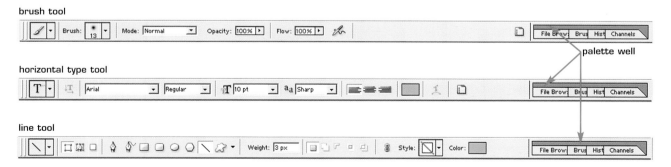

brush tool

horizontal type tool

line tool

The options bars are different for each tool activated. Some features remain unaltered, but others provide options likely to be of specific value with that tool. Here, the Brush tool has the brush size attached because it is needed, but the other bars do not.

Think of the whole thing as a mechanic's cantilevered toolbox. He gets to a job, opens the lid of the box, and there before him are the tools that were left on top the last time it was used – this is the toolbox view you see when you first open Photoshop. If the tool required is not visible, the mechanic pulls the handles apart to reveal tools lower down in the box – the equivalent of the hidden tool palettes. Having finally selected the tool, he then must decide whether any attachments or other devices are required to make the job easier – and this is the task of the options bar, which extends the possibilities of the toolbox.

As well as the individual tool options there is a very valuable Palette Well, which provides an on-screen storage place for the cumbersome palettes.

STATUS BAR

When it is not visible on-screen, the status bar is found under the Window menu. This is a rarely used interactive help device that is of great value, particularly to those who are new to the mysteries of Photoshop.

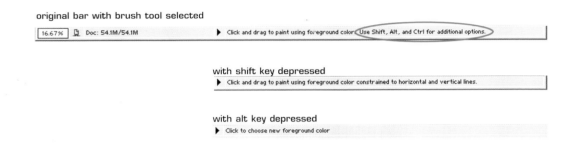

original bar with brush tool selected

with shift key depressed

with alt key depressed

The status bar is interactive and changes depending on what is happening on-screen. The original brush instructions change when the Shift or Alt keys are pressed, and these differences are detailed on the bar.

When a tool is selected a short instruction line appears here to tell you what is going to happen if it is used; this is helpful, but of even more value is the fact that it usually displays further options. In some instances the message changes even without selecting a new tool; for instance when moving inside or outside of a selection. If you are having trouble understanding what is happening on-screen at any time, it is worth glancing at the status bar, just to check that what you thought was about to happen coincides with what Photoshop thinks is going on!

MENU BAR

Tucked away within the menu bar are many of the powerhouse facilities of Photoshop. To access them, move across the bar to the appropriate name and then click to release the drop-down menu. Very few of the possibilities are active unless there is an image on-screen. The active and usable ones are darker in the menus, but the lighter ones, which are usually referred to as greyed-out, are inactive.

The drop-down menus often display keyboard shortcuts alongside. Small arrows alongside the words indicate that there are additional menus, activated by just moving on top of that name. If you wish to use one of these you must pull the mouse cursor across onto it without leaving the box, or it will disappear. Three dots after a name indicate that another dialogue box, with more options, will open if you click that item.

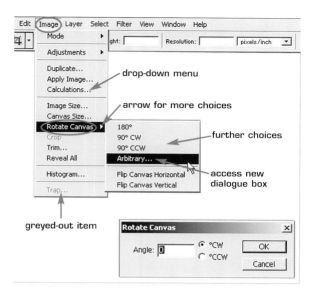

The drop-down menus contain cascading sub-menus, activated by clicking on the tiny black triangles alongside the words.

palettes sorted and docked

default palettes – not docked

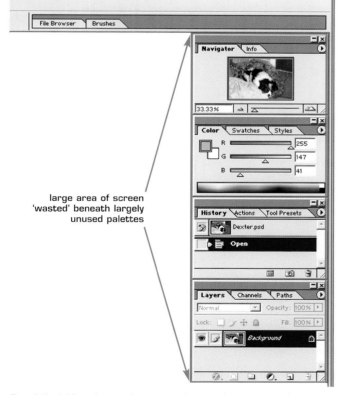

large area of screen 'wasted' beneath largely unused palettes

Carefully tidying the workspace and removing unwanted or infrequently used palettes, keeps the screen clear and uncluttered.

The Window menu holds all the invisible desktop items within it, and this is where they end up if you close them, inadvertently or otherwise. Just click to return them to the desktop.

PALETTES

These are one of the great strengths of Photoshop, allowing us to bring whichever ones we need onto the screen while 'losing' all the others. It's very important to work in a user-friendly and 'clean' workspace environment, and a little time spent here will be repaid over and over again.

It is extremely bad practice to just leave palettes scattered around, and one of your first jobs should be to decide which ones you will need regularly and which can be put away. The guidelines here suit my way of working, but there are no rules and you should customize the desktop to suit your own requirements.

Taking them in the default order, I rarely use either Navigator or Info; clicking on the X in the top of the box tucks them back into the Window menu and out of the way. I normally access colour from the large picker at the base of the toolbox; this is both easy to use and always on-screen, making the others superfluous other than for specialized purposes. Styles can be accessed from the menu bar when using the drawing tools, so again I remove this from the screen and recall it only when it is needed.

The History palette is indispensable, but rather than leaving it on-screen, covering parts of the viewing area, I place it into the Palette Well for instant access. Actions and Tool Presets are important to some users and may well be placed alongside the History palette, but I prefer to close them down and place them back on-screen as required. Layers and Channels are vital and should be placed into the Palette Well too. If you work with graphics frequently, also include Paths.

The overall difference that all this cleaning up makes to the working environment is massive – in the one case over a quarter of the screen is obscured, and in the other there is no clutter at all.

Colour choices

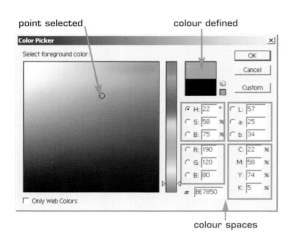

point selected colour defined

colour spaces

Each of the four sets of numbers represents a different way of defining numerically the specific colour value of a pixel.

COLOUR SPACES

No matter how you consider colour, it always comes back to the same thing, a set of numbers attached to each pixel in your image, and this provides the data to define the colour of that particular dot. Unfortunately, just to add further complexity, these numbers are not always the same, but change depending upon which of the colour modes is being used.

However, you should bear in mind that Photoshop is colour-blind and has no real understanding of colour other than through these numbers; the colour is an artificial thing imposed later to enable us to view or print the image.

Within the Color Picker, found at the base of the toolbox, there are four fundamental colour spaces that can be used to define the colour of a pixel.

RGB (Red, Green and Blue)

This is one of the two most used colour spaces, defining the image with just three numbers, one for each of the colours. When red, green and blue lights are mixed equally, white light results. This is the mode used for on-screen viewing.

CMYK (Cyan, Magenta, Yellow and Black)

This is the space most used by professional computer workers because it is used for printing. Theoretically if you mix cyan, magenta and yellow light together the result is black, but in the real world of inks, containing impurities, it produces a muddy brown colour, so black is included as a fourth ink. This is not a 'true' colour space in Photoshop, but merely a representation of what the colours may look like when printed out; they are not defined by numbers, but as percentages of each ink required to produce that colour. The colour wheels at right illustrate one of the problems of printing colours onto paper; they never look as pure and bright as those seen on-screen because very bright colours are always dulled down.

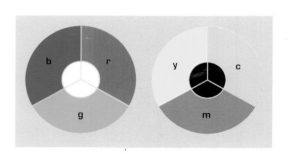

In RGB mode the overlap of the three colours produces white light. If the complementary colours of CMY are used, the overlap area appears black (K).

HSB (Hue, Saturation and Brightness)

This is a very user-friendly way of defining and handling colour, but unlike the previous two it is not a method that can be saved with your image. Think of it as a clever way of working with colour, rather than a basic defining mode.

Lab (Lightness, a and b channels)

This is Photoshop's own workspace, and is the colour space with the widest range of colours available. It is not an easy working mode and therefore is rarely used, but it is always busy beneath the surface, controlling among other things colour conversions, such as mode changes from RGB to CMYK.

With the exception of HSB, it is possible to see the multiple colour surfaces that make up our image. Each has its own channel that contains all the data for that particular colour. We shall look more closely at channels on page 92.

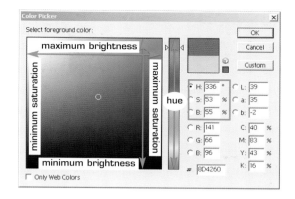

HSB is not like other methods of defining colour. It divides the colour into three component parts based upon that colour's position in the spectrum, and its light and saturation values.

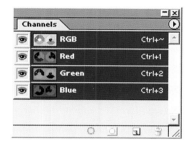

RGB

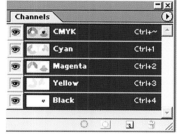

CMYK

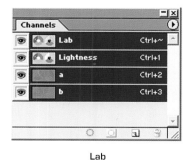

Lab

The Channels palette shows the individual colour channels for the different colour modes.

Within the Color Picker there are other options, including one for choosing Web-safe colours. This is a limited palette of 216 colours that will look the same on other people's computers, via the Web, as on your own. Click the small check box to activate the palette.

These different ways of working with colour can be extended even further under Image on the menu bar. Clicking on Mode gives access to other colour options, two to do with conversion to black-and-white images, Bitmap and Grayscale, and other more specialized colour modes.

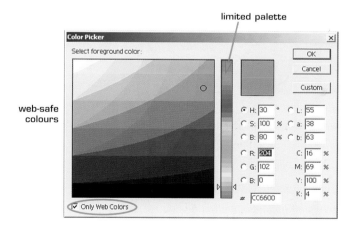

So that you can confidently prepare work for the Web, one of the palettes displays only Web-safe colours that will look the same on other people's computers as they do on your own.

CHOOSING COLOUR

The Color Picker is a very accurate way to select a colour, but it is not the only way. Under the Window menu there are other choices contained within 'Color', which, by default, contains both the Color and Swatches palettes.

Color palette

The Color palette is similar to the main Color Picker, in that you first click on the spectrum bar to select an overall colour range. Then, instead of moving within the coloured box, you refine the colour by moving the arrows along the bars until you find the one required. If you are working in a specialized field
• this way of choosing colour can be advantageous, since via the arrow in the corner of the palette it is possible to rearrange the way colours are displayed to suit any of the colour modes, for both the spectrum bar and the sliders.

Swatches

This appears to offer a more limited range of colours, but nothing is simple in Photoshop! The small arrow again reveals a massive choice of alternatives. If you are a printer working with a fixed range of inks, or a graphics designer working to a close brief, there are always specific swatches available; it's even possible to create your own personal swatches.

These palettes are really designed for the professional user, and you should always bear in mind that Adobe designed this program around them. The fact that it sometimes appears so complex and confusing simply reflects the many groups of people who use it, often for totally different purposes and in very different ways.

Simple though the basic Color Picker may be, even here there are hidden depths aimed at the professional user. Click on the Custom button and you have a vast choice of industry standard colour 'books' that define a printed colour precisely.

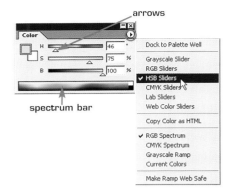

arrows

spectrum bar

Many additional colour palettes are available via the small arrow in the top right of the Color palette.

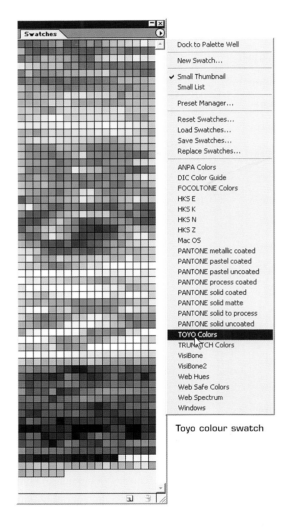

Toyo colour swatch

There are many swatches supplied ready for use, or you can design and save your own.

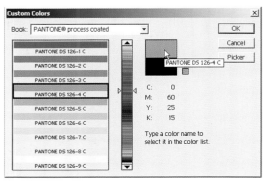

After selecting a colour 'book', the choice of individual colour can be made from the vertical bar and then selecting directly by its number.

So now you reach the critical decision – with all these choices, which one is right for you?

Normally, photographic workers work on and save their images in RGB, because this gives a wider range of colours on-screen and makes the photos appear more vibrant. If they are to be printed on an inkjet printer or similar, they would be printed as RGB files even though the printer itself uses CMYK inks, because most home/small-office printers are designed to make the conversions for you.

People working in the pre-press world, who know that their images will eventually be printed on commercial printing presses, will need at some point to convert to CMYK in order to view the 'dulling' effect that the conversion creates. The dramatic difference this can have is easily seen in Photoshop by clicking the triangle with the asterisk that sometimes appears as a warning alongside the current colour in Color Picker, when very bright colours are selected. When the coloured square beneath it is clicked, the circle defining the colour chosen will move to the nearest colour it is possible to print on a commercial CMYK press.

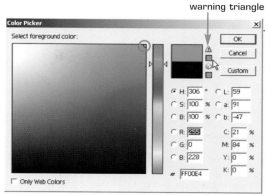

warning triangle

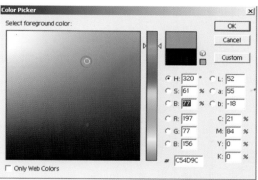

The selected bright RGB colour (top) looks fine on-screen, but when the image is converted to CMYK (above) the point moves to a much duller colour that is within the printable range.

Although difficult to see on the printed page, the CMYK dilution of colour can be clearly seen in this enlargement, particularly in the bright blue areas.

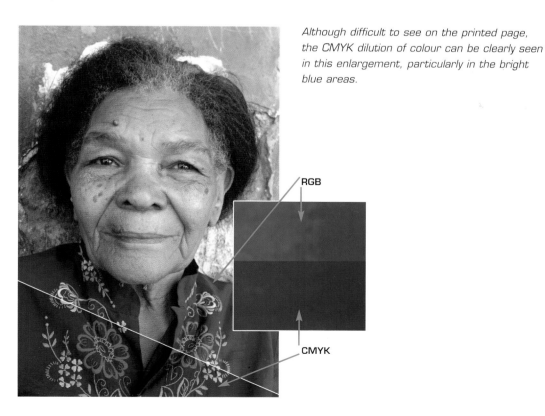

RGB

CMYK

Brush choices

BRUSHES ARE FUNDAMENTAL TO PHOTOSHOP. MANY ARE PRESET WITHIN THE PROGRAM, WHILE NUMEROUS OTHERS ARE AVAILABLE ON THE WEB. AND IF THE SELECTION PROVIDED IS NOT SUFFICIENT, YOU CAN BUILD YOUR OWN.

FINDING A BRUSH

There are two ways to access a brush: the first is via the Brush Preset picker to the left of the options bar, and the other by way of the Brushes palette, which toggles on and off at the other end of the bar. Whichever you go for, they only become available when you choose one of the brush tools from the toolbox.

Brushes used to be straightforward in earlier versions of Photoshop, but in common with many other things they have now been 'improved' so far that they have become, in my opinion, unnecessarily complex. Adobe added the presets so that user's own customized brushes could be saved, and a multitude of tick-boxes and sliders as well. I suspect few people actually make use of many of them! Here, I am going to keep it simple by using just one selection method – the Brushes palette.

The palette has two fundamental ways of displaying your brushes:

Brush Presets is the 'normal' palette when expanded.

Brush Tip Shape resembles the palette used in earlier versions of Photoshop, and includes a reshaping device below the main brush window.

Both viewers have multiple tick-boxes alongside, to allow numerous variations on the basic brush scheme.

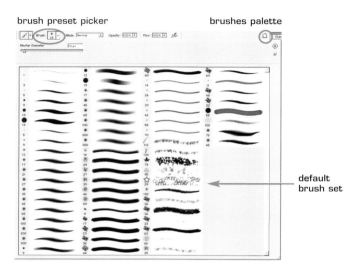

This is Photoshop's default brush set. Many more are available within the program.

tools that use the brushes palette

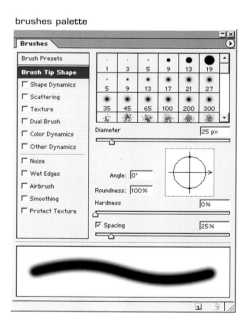

It is possible within the Brushes palette to define with great precision not only the type of brush required, but also just how you wish it to function.

USING BRUSHES

This is the easy bit. Just select any of the painting tools from the toolbox and make the following choices:

1 Choose a brush from the toolbox.
2 Open the Brushes palette.
3 Select brush type and size from the scrolling list to the right of the brush tip shapes.
4 Set required foreground colour from the Color Picker. This is the colour the chosen brush will apply to the image.
5 Make sure that the settings for Opacity, Mode and Flow on the Options bar are all as required.

Novice users are often confused by brush size values, which are measured in pixels; this means that sometimes they appear to change size. A brush tip of 100 pixels used on a small image would make a very large stroke, but on an image of many megabytes it would be barely discernable.

Moving the Diameter slider can also change the brush size, but undoubtedly the best way is to use the shortcut keys on the keyboard. The brush will increase in size every time the right-hand square brackets key is pressed and decrease with the left-hand square bracket key (alongside the letter P). This can be done at any time whilst painting and does not require the palette to be opened at all.

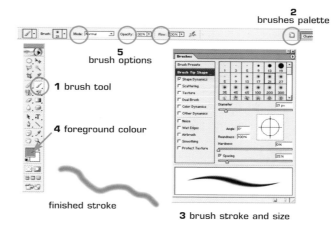

brushes palette

brush options

1 brush tool

4 foreground colour

finished stroke

3 brush stroke and size

Follow the sequence shown here, and there will be no surprises when the painting begins.

27-pixel brush applied to a large and a small image

The brush size used here is constant, but obscures more of the smaller image when in use, making it seem larger.

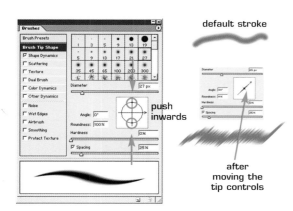

default stroke

push inwards

after moving the tip controls

Squeezing the points on the circle inwards has the effect of squashing the brush into an elliptical shape, ideal for calligraphy.

Once the selections have been made, any movement of the mouse on the image or blank canvas will produce a stroke of the chosen shape, using the selected foreground colour.

MODIFYING BRUSHES

The stroke drawn by a brush is almost infinitely variable. First, choose a paintbrush with a soft edge, or a pencil with aliased (hard) edges, but this is only the start.

Click on Brush Tip Shape within the Brushes palette to release the reshaping controls, allowing the default round brushes to be reformed. Click on either of the dots around the circle and then move them towards the centre to compress the brush into an elliptical shape; in this way calligraphic brushes can be created. Angle and Roundness reflect the degree of distortion and movement of the circle.

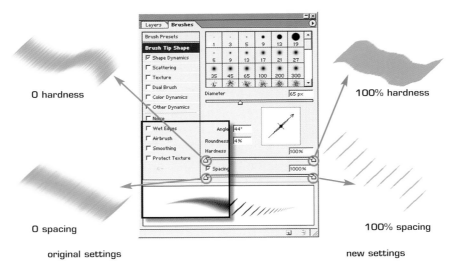

O hardness

O spacing

original settings

100% hardness

100% spacing

new settings

Moving the Hardness and Spacing sliders can have a dramatic effect upon the finished brush.

Hardness determines whether you want the brush to behave like a pencil, or to have anti-aliased edges like a soft paintbrush. Spacing is an interesting variant that breaks up the continuous line of paint and instead presents it onto the page as a series of individual brush marks, following a line. The more the slider is moved, the greater the separation of the individual strokes.

Alongside the brush tips is an enormous armoury of devices to produce wonderful, as well as wild and wacky, brush strokes. It would be difficult to go into all the many variants listed here – it's better to just sit and experiment with them – but some general guidance on the options is needed.

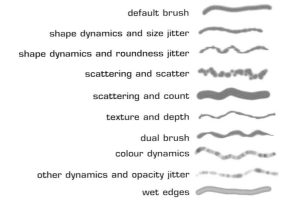

default brush
shape dynamics and size jitter
shape dynamics and roundness jitter
scattering and scatter
scattering and count
texture and depth
dual brush
colour dynamics
other dynamics and opacity jitter
wet edges

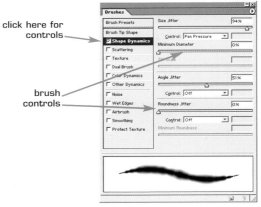

click here for controls

brush controls

Some of the many strange and creative strokes produced from a single default paintbrush, modified using the brush controls.

When you select one of the variants it is not sufficient to just tick the box; this does not access the controls for it. Clicking on the name alongside activates both the box and the necessary options. Several strange terms appear in here:

Scatter Refers to the number of marks made in a stroke and their placement. The marks will be displaced perpendicular to the stroke made unless Both Axes is checked, when they will be spread evenly around.

Count Determines the number of brush marks made at each point along the stroke.

Jitter This is an important one, since it specifies how randomly spread the marks will be; higher percentages make the strokes more randomly distributed.

Control Most of the adjustments allow additional controls via a drop-down list. With the exception of Off and Fade – which fades away a stroke produced by a mouse – they all refer to the use of a graphics pad rather than a mouse.

The viewing area beneath the controls is a very useful device to let you see the brush and its effects before you actually use it. This is a running preview that takes into account all of the changes made.

MOUSE V. TABLET

It would be remiss not to mention the use of graphics pads here. Adobe have worked very closely with Wacom, the leading graphics pad developer, for some years, and the fruit of this is to be found within the brushes palette.

Graphics pads, sometimes referred to as tablets, replace or supplement the mouse; instead of pushing and clicking, these are operated by a stylus, resembling a pen, and you draw upon the pad to position the cursor. There are customizable buttons on the stylus, but you can normally manage without them, since rather than clicking to carry out the action, you touch the pen onto the pad.

If this were the whole story tablets would simply be a mouse replacement, but they are much more than that. The stylus tip is pressure-sensitive, which allows precise control. When painting, if you press gently it will produce a pale transparent wash of the foreground colour, but if you press harder, it will totally replace whatever is already there, in the same way as a mouse would.

Graphics tablets add a whole new level of functionality to Photoshop that cannot be obtained in any other way, but be warned that there is also a down side.

Computer users have become accustomed to pushing the plastic brick that we call a mouse around a pad, and we totally ignore the fact that if we lift and move it, the cursor stays in the same place on-screen. Graphics tablets behave like a pen on paper, and there is a positive positioning between the pad and the stylus, if you move the pen to the top right of the pad that is where the cursor is on-screen. Initially this makes it awkward for many users, and I have known people buy one and then abandon it almost instantly. Don't!

It is worth buying a pad for all the extra functions it provides, but be prepared to give yourself a week or so to get used to it; by the end you will be totally hooked.

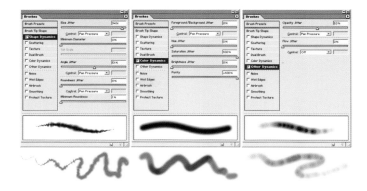

A few of the many strokes that become possible when using a graphics pad.

Adobe work closely with the leading graphics tablet manufacturer. Although only A6 size (10.5 x 7.5cm/4$^{1}/_{8}$ x 3in), this model is more than adequate for most photographic purposes.

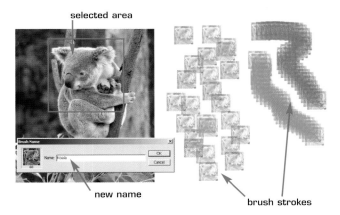

selected area

new name

brush strokes

It is very easy to define your own brush shape from an image. This may then be 'dabbed' to create miniature painted versions, or used conventionally.

CREATING AND SAVING 'SPECIAL' BRUSHES

Apart from the numerous standard brushes, it is possible to make your own from virtually anything. Using any picture as the start point, select the Marquee tool from the toolbox and draw a selection around the area you wish to use as your brush tip. Now select Edit > Define Brush and a box appears with a black-and-white impression of the area; name it here if you wish. The brush adds itself to the base of the palette and can be selected like any other.

Remember that if you have made and modified a brush to your own specification that you may wish to use again, it is a good idea to save it as a preset. Click on the Brush Preset picker to reveal the dialogue box; choose the arrow in the top right corner and then click on New Brush.

Finally, if you want to save the time and effort of designing your own brushes, there are thousands of them on the Web, many of them free. Type something like 'Photoshop brushes' into your browser and prepare to be astonished by the number that appear!

Mask basics
MASKING ALLOWS VERY PRECISE AND CONTROLLED ALTERATION OF ANY IMAGE, AND IF PHOTOSHOP IS TO BE MASTERED, IT IS IMPORTANT THAT YOU UNDERSTAND MASKING AND ARE CONFIDENT IN WORKING WITH THIS METHOD.

WHAT ARE MASKS?

When designers and photographers work on an image, they frequently protect part of it with transparent masking film before they begin to paint. This allows them to spray an area without having to worry about the colour going in the wrong place. Photoshop has a similar but much more controllable device, which magically simulates the effect of masking and enables very precise control.

Near the base of the toolbox are two buttons; the first one works in Standard mode, but the second one immediately takes you into Quick Mask mode. As it does so a number of changes take place:

- RGB, or whatever colour you are working in on that particular image, disappears from the title bar and is replaced by the words 'Quick Mask'.
- Any colour in the palettes at the bottom of the toolbox is replaced by the default black and white.
- If the Channels palette is open on the desktop, a new Quick Mask channel appears at the bottom of the palette, represented by a white rectangle.

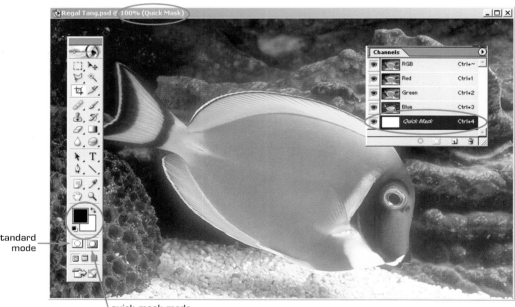

standard mode

quick mask mode

Photoshop changes the working colours to black and white, because masking uses only grey tones, not colour, and removes the coloured RGB label from the title bar to show that it is now working as a mask. Channels determine the basic colour of an image, but it is worth noting that using masks does not alter these in any way, but instead a new separate channel is created to work on.

Clicking the mask icon at the base of the toolbox accesses Quick Mask. A number of changes take place when it is clicked.

APPLYING MASKS

Masking is simply painting onto a mask instead of directly onto the image. If you worked with the black-and-white defaults used for masking you would be unable to see the image through the mask, therefore the masked surface is shown within Photoshop as being red. This can be terribly confusing when you first start, so here it is again: when you paint your mask using the default foreground colour of black, the stroke painted appears on the mask over the image not as a black paint stroke, but as a semi-transparent red one; this is purely so that you can see the image through it. If you happened to be working on a red surface it would be impossible to see the mask, so Adobe made it possible to change the colour of the masking by double-clicking the Quick Mask symbol in the toolbox.

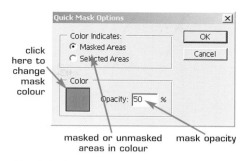

click here to change mask colour

masked or unmasked areas in colour

mask opacity

The default mask colour can be changed to any convenient colour of choice.

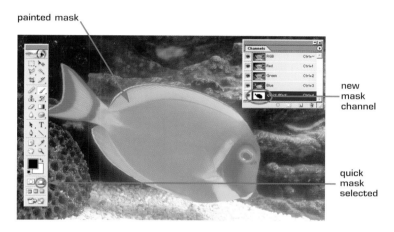

painted mask

new mask channel

quick mask selected

The semi-transparent masking can be easily seen while painting, but the mask colour will not damage the image in any way.

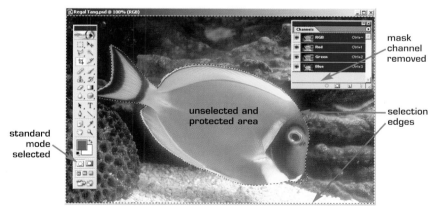

mask channel removed

standard mode selected

unselected and protected area

selection edges

The background has been selected and therefore is the only 'active' part of the image. The fish is fully protected by the mask.

To demonstrate the possibilities the selected area has been blurred, making the fish more dominant, as though it were standing away from the background.

The basic idea is to first click on the Quick Mask symbol, to enter the masking mode, and then select a suitable brush to paint over the part of your image that you want to protect. In this case you are going to protect the fish but change the background, so use a conventional paintbrush and paint directly on top of the image. It will look as though you are ruining the photo, but don't worry – all the apparent damage is just the red of the mask and will go when you come back out of Quick Mask.

It's OK to change brush size and type while masking, and it usually works well to paint the main area with a large paintbrush and then zoom out to the edges to complete the task with a smaller brush. When the masking is complete, a single click on the Standard Mode button alongside the Quick Mask symbol in the toolbox clears the mask and replaces it with a selection. Selections are fully discussed in the next chapter, but suffice to say here that they define the active area of a picture. It is therefore now possible to modify this outer background area without having any effect upon the masked, and therefore protected, part.

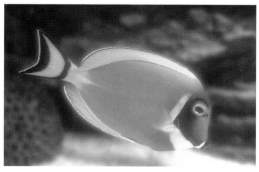

PARTIAL MASKING

Sometimes partial masking is required in circumstances where objects are transparent. Think of windblown hair, where you can see through it to the colour of any object behind, or looking through glass; it would seem very strange if there were no differentiation between that area and the rest of the image when any changes have been made.

To allow for this, it is possible to paint with any shade of grey onto the mask. Painting with a very dark grey will almost fully protect the image beneath it, but when you paint with lighter greys these will progressively expose more and more of the image to any subsequent action.

When masking a complex photo that requires transparency, it is therefore possible to mask the main area entirely by painting with black, but to use lighter shades for masking semi-transparent areas. Using a shade of grey over the car windscreen below ensured that it can still be seen through, but because of the changed opacity of the mask, it does not have the same appearance as the background.

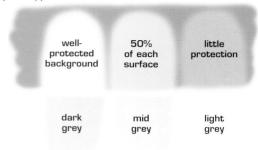

paint applied over masked areas

well-protected background	50% of each surface	little protection
dark grey	mid grey	light grey

painted mask

As the painted red mask becomes lighter it allows more of the original colour to show through.

original image

new background added

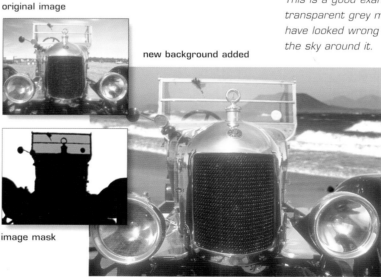

image mask

This is a good example of the use of semi-transparent grey masking. The windscreen would have looked wrong if it had the same opacity as the sky around it.

GRADIENT MASKS

A delightful variant of masking with a paintbrush, which utilizes fully Photoshop's ability to change the density of a mask, is the use of the Gradient tool as a masking device. This clever tool is discussed on page 52, together with all the other tools, but it would be remiss not to mention its connection with masking here.

The Gradient tool has the ability to apply tones from black to white along a line onto a mask, and the join cannot be detected because of the gentleness of the resulting transition. This means that it is an ideal way of creating seamless masks within an image.

In the sequence below, having first activated Quick Mask by clicking on the symbol, and after selecting the Gradient tool from the toolbox, it was simply a matter of drawing a line across the photo from left to right to produce the gradient. The foreground and background colours had been set to black and white respectively.

original image

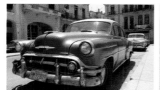

gradient mask completed

selected area

finished image

The Gradient mask used in these images has created a transition so gentle that no join is apparent.

The gradient drawn produced a solid mask to the left of the image, where the darker paint was applied at the start of the line, but as the tones faded from black to white across it the density of the mask being drawn was diluted, allowing more of the area to the right to be exposed to any further action taken. Clicking on Standard Mode created a selection from the mask, and this, although it appeared to cover only half of the image, was actually marking the centre point of a very soft transition from masked areas to unmasked ones across the whole picture.

Any effect applied now will merge seamlessly from one side to the other. We simply applied a filter to it to show the result, but any other technique could be used. One obvious photographic application of a gradient mask is to use it as you would a polarizing filter, to darken the upper area of a too bright sky.

Using a Gradient mask, the sky has been made to appear as if it had been taken with a conventional polarizing filter attached to the lens of the camera.

TOOLS

Selections

THE ABILITY TO SELECT AN AREA AND THEN CHANGE IT IS CRITICAL TO WORKING IN PHOTOSHOP. SELECTIONS CAN BE MADE IN SEVERAL DIFFERENT WAYS, BUT WE WILL LOOK HERE AT THOSE THAT CAN BE MADE USING THE BASIC TOOLS.

Using the Rectangular Marquee tool, a selection has been made and then desaturated. Only the selected pixels are changed.

WHAT IS A SELECTION?

If you isolate part of an image by drawing around it with one of the Lasso tools, or by using Photoshop's amazing ability to separate colours, the area enclosed by that line is known as a selection. Once the selection has been divided from the rest of the picture, and while it remains selected, it is the only active part of the image; any alterations can only happen within the selected area.

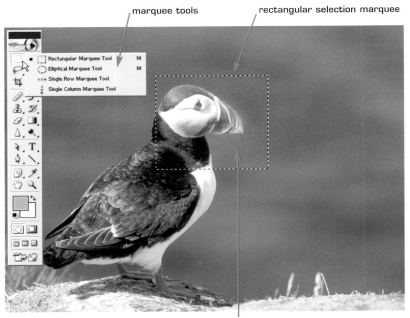

marquee tools rectangular selection marquee

desaturation only occurs within the selected area

THE MARQUEE TOOLS

Right at the top of the toolbox are the Marquee tools; these allow regular-shaped selections to be drawn.

After selecting the Rectangular Marquee tool and then clicking and dragging the mouse within the image, a rectangular moving line – known affectionately as 'marching ants' – is left behind. The initial click determines the first corner of the rectangle, but the shape and size are governed by where you release the mouse. The further away from the start point this is, the larger the rectangle will be.

Clicking and holding the mouse over the rectangular marquee button reveals other options. The Elliptical Marquee tool makes selections with rounded corners but still behaves as if it was in a box. To select an elliptical shape you have to first click away from the edge of that shape, on the corner of an imaginary rectangle drawn around it. This takes practice to get right.

The Single Row and Single Column Marquee options are of limited use, but they provide an accurate, one-pixel wide, vertical or horizontal line across the image.

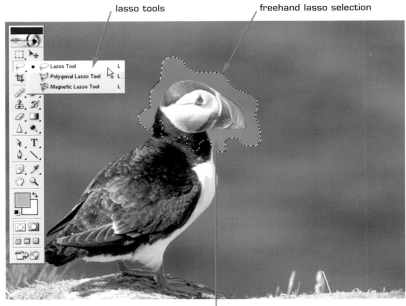

lasso tools freehand lasso selection

colour changes only within the selected shape

The Lasso tools facilitate the drawing of irregular-shaped selections. Once selected, changes are still confined to the selection only, whatever its shape.

THE LASSO TOOLS

The most valuable line-selection tools are undoubtedly the three Lasso tools. They all allow you to draw a selection line around an object, but use different methods to achieve it.

The Lasso tool works as a freehand drawing tool, requiring the operator to draw around the edge. Click on the start point and move along the edge required, holding the button down, until the selection is completed; when the mouse button is released it will automatically connect that position to the start point and complete the selection. Don't make the mistake of clicking twice or it will all disappear – but if you do, stop immediately and press Control and Z on the keyboard to get the selection back.

The trick when selecting with this method is to work very large, so that it is easy to follow the edge. When you zoom out, any deviation from the 'perfect' line will be compressed and therefore less visible. Even easier is to work with a graphics tablet, a device built for the task (see page 36).

(see page 36)

magnified image

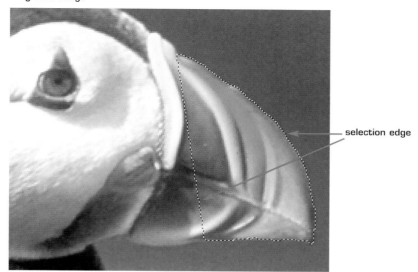

selection edge

Magnifying the image before drawing the selection gives much greater accuracy, because when zoomed out, minor deviations do not show.

Some people find this way of working difficult and prefer to use the Polygonal Lasso tool. This is similar to the Lasso tool, but instead of drawing continuously the outline is plotted using short lines. This may appear to be limiting, but it is not.

The first click sets an anchor point, and moving the mouse drags a line away from it; a further click places another anchor and the line is drawn between the two points. This continues until the selection is completed. The beauty of this method is that it allows you to take time selecting the points and to pause if you wish.

If a mistake is made when an anchor point is placed, it is possible to go back to earlier points by simply pressing the backspace key on the keyboard. If you inadvertently double-click, that point will connect with the first one and complete the selection. Pressing backspace now will not reverse it, but thankfully there are other ways to modify the initial selection.

polygonal lasso selection

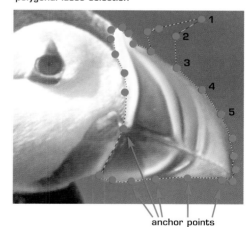

anchor points

The first two points are drawn away from the edge to be selected and clearly show the straight-line construction. Where the curved edge is complex, more and closer points are needed.

The Magnetic Lasso tool attempts to make the selection for you! The cursor here has a circular brush that can be adjusted by increasing the number in the Width box on the options bar. As the circle is moved over the pixels Photoshop 'reads' the image to determine where the most significant edge is, and places a selection line upon it.
If the edge to be selected is obvious, the brush can be made large and drawn quickly over it with Edge Contrast set high, but if the edge is subtle it will be necessary to reduce the brush size, lower Edge Contrast, and move the mouse more carefully.

Keep an eye on any sharp change of direction with the mouse if you decide to select in this way. Frequently the Magnetic Lasso tool cuts corners and does not follow the required line sufficiently well; however, corrections can always be made afterwards.

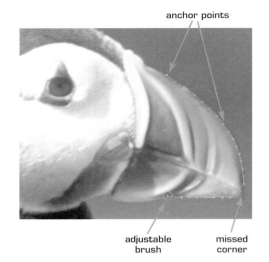

anchor points

adjustable brush

missed corner

As the brush moves over the image the Magnetic Lasso tool attempts to identify any edge found beneath it. Anchor points are placed to allow further adjustment where necessary.

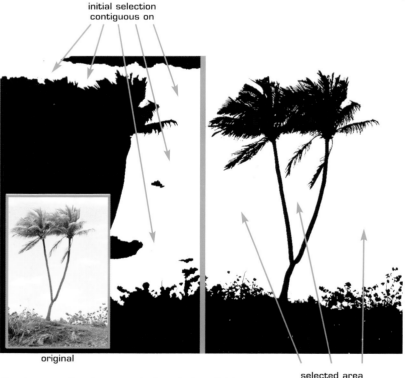

initial selection contiguous on

original

selected area contiguous off

Contiguous will select any similar pixels adjoining the one first clicked upon. When it is switched off, any similar pixel will be included in the selection, whether touching the original or not.

MAGIC WAND TOOL

This one is wonderful! Click anywhere in an image and a complex selection appears as if by magic, hence the name. What actually happens is that Photoshop looks at the values of the pixel clicked first, and then adds other pixels of similar values to it to create the selection.

Where you first click, and the settings used, are critical to the final outcome. By default Tolerance is set to 32 and this is the numerical value that is added or subtracted to the original pixel values, to determine whether other pixels are similar enough to be included within the selected area. It therefore follows that if the Tolerance figure is small, only pixels very similar to the original one will be included, but if it is large, many colours will be added. In use this really is magic – if an area within an image is all of a similar colour, such as the sky, it is often possible to select it, no matter how complex, with just a few key clicks.

The Contiguous option lets you choose between just those pixels that are in contact with the original, or pixels anywhere in the image that are within the tolerance setting. In a situation where there are leaves in front of a sky, for instance, it is wise to switch off Contiguous, click the sky colour to select it, and miraculously every little patch of sky showing through the leaves will also be selected.

MODIFYING SELECTIONS

All these selection methods work together, and other options exist to allow refinement of any selection made.

On the left of the options bar is a series of four icons. The single rectangle is used to make a 'New selection'. If a selection is already active in the image it will simply delete it and begin again, so beware! Once a selection is in place, clicking on the second 'Add to selection' icon and making a second selection will not remove the original one, but will add more pixels to it. The third icon, 'Subtract from selection' removes any overlapping pixels from the original selection. The final icon, 'Intersect with selection' will leave selected only those pixels that are common to both the original and the new selection.

Collectively, these selection tools are very powerful. It is possible to make a quick rough selection of the area required, and then make additions and subtractions at high magnifications until the selection is perfect. Feathering is also available throughout this process, or when the selection is complete, to soften the edges before any changes are made to the image.

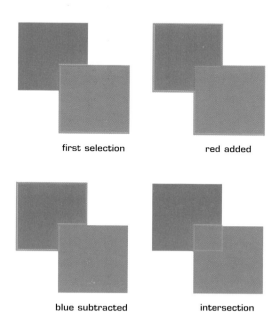

first selection red added

blue subtracted intersection

Using the option bar icons, it is possible to modify the initial selection by including or excluding parts of any new selection.

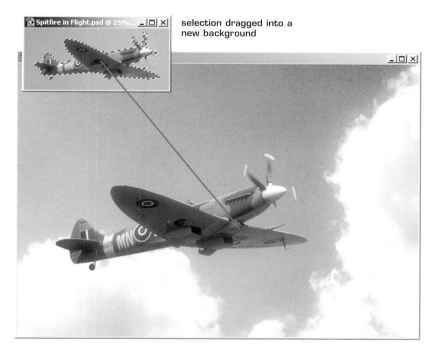

selection dragged into a new background

Selecting and dragging an image from one photo to another is an effective way of changing the background.

MOVING SELECTIONS

Once selections have been completed, apart from being able to alter the content of that area, you can also move it or copy it.

When placed over a selection, the Move tool (keyboard shortcut V) has a pair of scissors attached to the cursor. When clicked it will pick that area up and, if the mouse is kept pressed, remove it from the image and place it elsewhere. This can be within the existing image, but it also works between different images.

If the Alt key is pressed before moving the mouse, a double arrow cursor appears, which allows the selected area to be copied instead of being totally removed. This can be valuable if you want to have identical items within an image.

SAVING SELECTIONS

Having gone to the trouble of making a complex selection, it pays to always save it. Any competent Photoshop user will vouch for the value of this – redoing a lengthy selection because you forgot to save it is not an enviable experience!

Under select on the menu bar there are a number of ways to modify your selections together with the all-important Save Selection option. You are given the opportunity to name it if you wish, and a new channel will be added to your image known as an Alpha channel – see page 96 for more information on Alpha channels.

If you remember to save your selection it is then possible to return later and reinstate the selection to precisely the same position within the image, even though it was previously deselected. Once a selection has been saved the Load Selection option becomes usable and you can choose from the list any selection that has been saved.

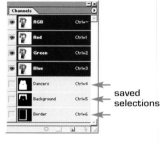

saved selections

Saved selections are recorded at the base of the Channels palette. If they have been named, the name will appear alongside the selection.

load and save selection options

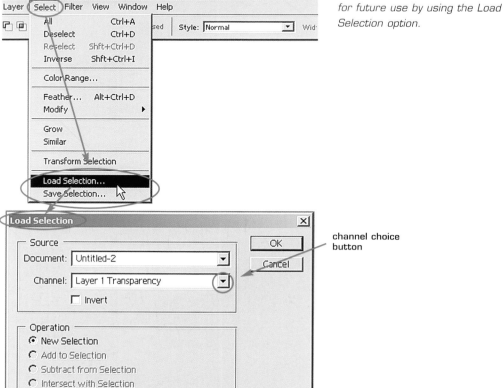

Having saved a selection it is available for future use by using the Load Selection option.

channel choice button

THE CROP TOOL

When you take a photograph with a camera the shape of the resultant photo is not always as you would like it; you can then trim off those areas not required – this process is referred to as cropping. Cropping an image is a specialized form of selection.

The Crop tool works like the Rectangular Marquee tool, but with one big difference – when the mouse button is released and the selection appears, it has control handles around it, allowing further modification. The handles appear in each corner and midway along the edges, while the area outside the selection turns darker.

Pulling the centre handles extends the height or width only, whereas pulling on any of the corners alters both dimensions. If the cursor is moved outside the selected area it turns into a curved arrow, and it is now possible to rotate the image around the central pivot point.

In addition to using this tool for straight-forward cropping, it is very valuable also for correcting misaligned images, such as a sloping horizon. Place one side of the cropping box onto the horizon and then rotate the box to align with it. Once parallel, pull the edge of the crop box out again. Press Enter to complete the action.

The possibilities for the basic selection tools are endless, and it is well worth spending time getting to grips with them because they will be used time and time again as you delve deeper into the program.

rotation arrow

crop box

handles

masked area to be discarded

pivot point

It's very easy to reduce the size of your image and alter its shape by using the Crop tool.

handle pulled upwards

horizontal aligned with edge of crop box

Known vertical or horizontal lines in an image, such as the horizon, can be easily aligned with the Crop tool.

Adding colour

THERE ARE NUMEROUS WAYS OF ADDING COLOUR IN PHOTOSHOP, USUALLY REFERRED TO AS 'PAINTING'. THESE METHODS ARE LOOSELY GROUPED TOGETHER IN THE TOOLBOX, AND RANGE FROM THE COMPARATIVELY SIMPLE TO THE MORE COMPLEX.

THE PAINT 'BRUSHES'

As you move across an image with a brush selected and the mouse depressed, the foreground colour is placed along the line. All the brushes work in this way, even though the finished result may appear quite different.

The Brush tool by default draws a line that has soft (anti-aliased) edges and the colour is applied at full opacity from the moment you press the mouse until it is released again. Within the options bar there are a number of ways to modify the way it works:

- Clicking the **Brush** icon allows you to change the width of the stroke made, or to choose different-shaped brushes.

- **Modes** are complex devices that are difficult to understand, but in essence they are a calculation by the computer of the result of applying the brush colour being used over the top of the image colour at that point. Don't worry about them; if you are seeking a special effect try them, and simply undo the result if it is not what you want.

- **Opacity** makes the applied paint transparent according to the values set, so that if you pass over another colour in the image, some of that colour will still be visible through the stroke being made. This value can be changed using the keyboard numbers: 10 is 10%, 20 is 20% and so on.

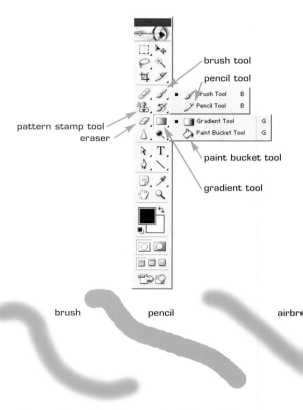

Even when using the same basic brush, the strokes produced can appear very different when applied as an airbrush or a pencil.

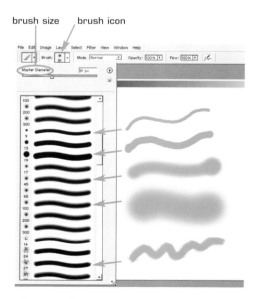

A single click on the brush icon on the options bar releases the Brushes palette, offering numerous brush shapes and sizes.

Complex Blending modes compare the colour being painted with the one it is being applied over, and calculate the result – not always predictable!

- **Flow** is very similar; this method applies the paint at full opacity, to obscure the image below it, but reduces the actual flow of that colour. Confused? You and everyone else! There is, however, a subtle difference in the result, though it is difficult to think why you would ever want to use it.

- The **Airbrush** icon makes the normal brush behave as if it were an airbrush. The edge of the stroke is softer, and if you pause over a point the paint will continue to flow and begin to spread outwards, beyond the actual width of the brush. The differences between this brush and the other variations are quite slight.

The Pencil tool, found beneath the Brush tool icon in the toolbox, behaves in a similar way to the Brush tool, but the edge is always aliased and hard-edged. If the line is drawn diagonally it can be very obvious. The Auto Erase option causes the brush to draw with the background colour if you start on top of a previously drawn foreground colour, but with the foreground colour if you start anywhere else!

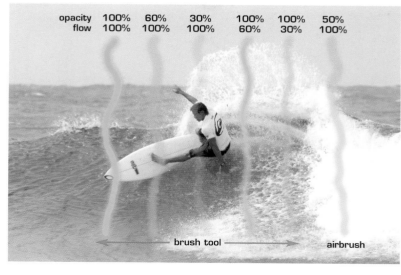

Changing the numerical values for Opacity and Flow affects the density of the paint applied.

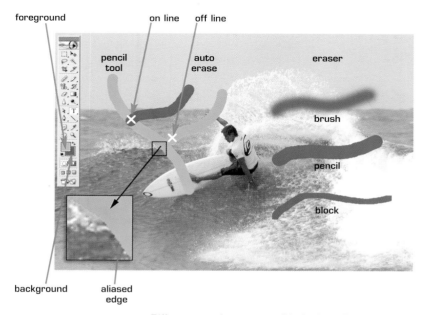

Different results are possible in Auto Erase, depending on where the line is started.

The Eraser tool behaves similarly to the brushes but removes paint, or the image itself, instead of covering it over with new paint. The modes here are not true blending modes, but they offer a choice of using the eraser in any of the ways already described, plus an additional option to block-erase with a square-shaped eraser.

New users are often confused by the colour that results after using the eraser. If you are working on a single surface with the Erase tool it will look as though you are painting with the background colour, since this is the colour of the imaginary canvas behind your image. If, on the other hand, you are working on a layer, it erases that surface and allows you to see the layer below through the erased hole.

GRADIENT TOOL

This is a more specialized form of painting, and needs to be looked at closely since it has a number of useful applications.

In its default condition the Gradient tool uses the foreground and background colours to draw a seamless ramp of colour from one to the other. Press the mouse button and drag it across the image and a line appears – it is along this line that the colour ramp is formed.

The foreground colour, as selected in the palette, is always placed at the start of the line, and the background colour at the point where the mouse is released and the line stops. Everything in the direction of the line before the first mouse click is the full foreground colour, and everything after the last click is the background colour. The linear gradient is always enclosed between the two ends of the line.

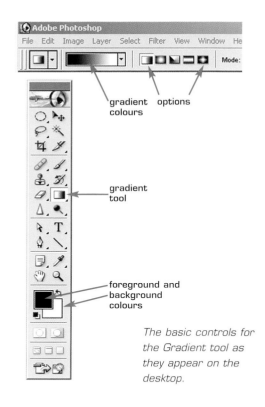

gradient colours
options

gradient tool

foreground and background colours

The basic controls for the Gradient tool as they appear on the desktop.

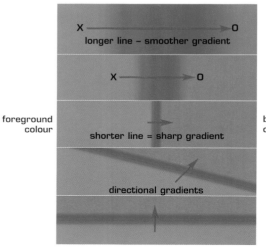

X ——————————→ O
longer line – smoother gradient

X ——————→ O

foreground colour

background colour

shorter line = sharp gradient

directional gradients

The line drawn using the Gradient tool controls its direction and smoothness.

Line length controls the smoothness of the transition from one colour to the other. If the line is short, the colours will change rapidly from one to the other, but if it is long, there will be a very gentle merging between them. The direction of the gradient is determined by the angle of the line and always forms at right angles to the direction travelled.

The gradient colours are infinitely variable, and are not just restricted to the default background and foreground. A single click on the colour ramp in the options bar reveals the Gradient Editor and other preset gradients.

Click on any of the presets and the ramp colours change dramatically. They are no longer restricted to just two solid colours, but may also include multiple colour choices and varying opacity. Drawing with any of the presets means that their particular attributes are applied to the gradient in the same way as described above.

basic gradient editor

The powerful Gradient Editor allows infinite variation of colours and where they are positioned within the transition.

TOOLS **10** ADDING COLOUR

In addition to the presets. it's possible to devise your own gradients:

Opacity

Double-click on either of the Opacity stops above the gradient, and its associated arrow will turn black to indicate that this is the point being edited. If you now change the opacity value within the box, the gradient will be made more transparent at this point. It's also possible to move that point by placing a number in the Opacity percentage box, but it is much more intuitive to actually drag the point along the line to the required position.

New opacity stops can be added by clicking at any point above the gradient to insert another control point. If you change your mind they can be deleted by dragging the point upwards.

Colour

Double-clicking on the squares beneath the gradient brings up the Color Picker, allowing you to choose any of the available colour options. Additional colour stops can be added as required and may be removed by pulling downwards from the gradient.

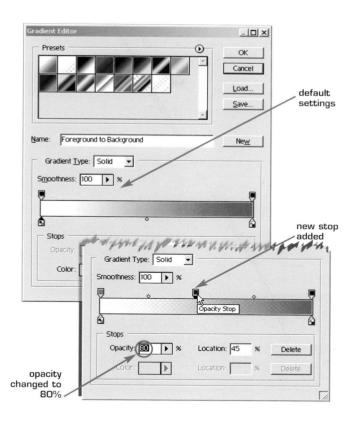

Density of colour at any point on the gradient is controlled by the value inserted into the Opacity box.

All these effects are revealed in the Gradient Editor as they are applied, and therefore it is pretty easy to view the finished product. There are options here to name any new gradients you feel might be used again; they can be preserved by using the Save button within the dialogue box.

The possibilities here are endless, and the best way to familiarize yourself with Gradient Editor is simply to sit and play with it for a while. While doing so, try the Noise option alongside gradient type: this is a weird one that introduces interference to the gradient. Randomize will cycle through possibilities as you click and allow you to search for a suitable result.

There are also other gradient presets to be found hidden within the Gradients folder, which are accessed via the Load button. Click on the list and add any Gradient palette you wish. Clicking the New button will add the currently displayed gradient to the list of presets found in the options bar.

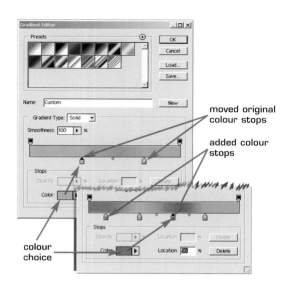

At any point on the gradient colour can be changed easily by adding additional colour stops.

GRADIENT SHAPE

Gradients are not necessarily linear; the five icons on the options bar provide other possibilities:

Radial Gradient

This will draw a gradient on a line as before, but the start of that line determines the only place that will be fully the foreground colour. As you move from this point the gradient merges radially into the background colour.

Angle Gradient

The line here determines a sharp division between the start and finish colours, with the gradient extending around a circle from one side of the line to the other.

Reflected Gradient

The 'normal' gradient here is copied back beyond the start point, and resembles a reflection.

Diamond Gradient

This takes the gradient and repeats it in each of four segments, forming a diamond pattern.

Reverse draws the gradient from background to foreground; **Dither** makes the gradient smoother; **Transparency** is complex and involves drawing on the gradient's mask.

There are many more gradients than those displayed by default; they are accessed from the arrow at the top of the palette.

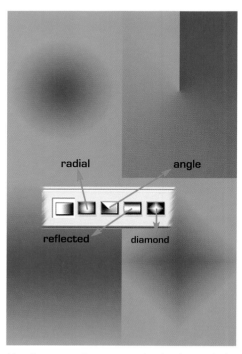

Non-linear gradients may also be formed after selecting from the buttons available on the options bar.

PAINT BUCKET TOOL

Tucked away beneath the Gradient tool is the Paint Bucket. Selecting this tool and then clicking in an image fills all those areas that are similarly coloured with the current foreground colour. Although a little confusing at first, it is actually just like making a Magic Wand selection and then filling it with colour.

Increasing the Tolerance figure will extend the range of colours that are to be filled until ultimately, at a setting of 255, all the pixels will be repainted in the foreground colour. They will all be filled before this figure is reached if they are very similarly coloured at the start!

PATTERN STAMP TOOL

This is a rather strange painting tool, found beneath the Clone Stamp tool, which does not behave like the other brush tools.

Click and paint with this tool and anything can happen, depending upon the pattern selected! The brush attributes are all as before, but the 'colour' applied is determined by the design chosen from the Pattern box on the options bar.

Click on the arrow alongside the box, and by default a small number of choices are available. A further click on the arrow within the box gives the opportunity to load additional patterns. After selecting one, any paint operation using this tool will apply that pattern as if it were paint, onto the surface of the image.

You can even make your own patterns by selecting part of an image – but not too big or you will regret it – and then using Edit > Define Pattern. This new pattern will be added to the rest and can be selected and used in exactly the same way.

tolerance 32 *tolerance 62*

If a higher Tolerance is applied to the Paint Bucket tool, the area painted will be more extensive.

The Pattern tool is a highly specialized form of painting, and is only loosely allied to the 'normal' brushes.

Numerous additional patterns can be obtained from the Web, many of them free of charge. This selection was downloaded from www.psextras.com.

Changing areas

THERE ARE MANY WAYS TO CHANGE AN IMAGE, APART FROM THE OBVIOUS ONE OF CHANGING COLOURS. THE BASIC ONES ARE LOOKED AT HERE, AND THE MORE COMPLEX CLONING DEVICES ARE EXAMINED IN THE NEXT CHAPTER.

BLUR TOOL

The Blur, Sharpen and Smudge tools are all contained within the one button on the toolbox. If it is not already on top, just click on whichever of these is visible, and then release the mouse over the tool required.

Clicking and dragging in the image with the Blur tool selected merges together the pixels over which the brush passes, therefore blurring them. By default the extent of blurring is set to 50% strength, but to avoid things happening too quickly, it's a good idea to reduce this figure down to about 10% and keep working over the area until it looks right.

The main tools for changing the image are grouped together within Photoshop's toolbox.

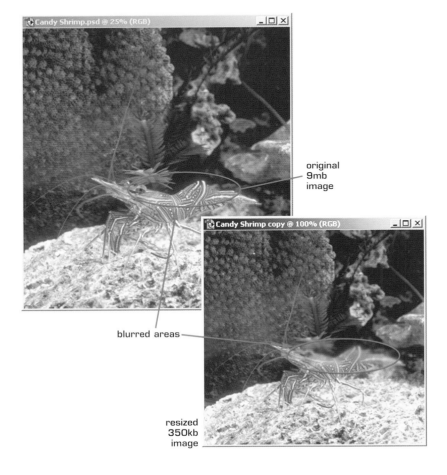

original 9mb image

blurred areas

resized 350kb image

The size and shape of the blur are changed in the same way as if it were a brush used for painting. The Mode control has a limited range of options, but they are all pretty meaningless, allowing the blur to change specific attributes of the colour or tone only. Forget it!

When using the Blur tool, remember that the strength of the effect is very much controlled by the size of the image. In a large image with many pixels, blurring together adjacent pixels in the image is barely discernible, but when the same degree of blurring is applied to an image with few pixels, the results are both dramatic and immediately obvious.

A given amount of blur will produce a much more noticeable change within a smaller image.

Painting over the background with the Blur tool gives an illusion of sharpness, making the foreground appear more prominent. The pebbles in the right foreground have been left untouched.

SHARPEN TOOL

Unsurprisingly, the Sharpen tool attempts to achieve the opposite effect to the Blur tool, but it is much less successful.

Blurring adjacent pixels on a computer is ridiculously easy since, in its basic form, it simply quantifies the colour values beneath the brush and then replaces the original colours with a softened, anti-aliased ramp of colours between the two, much like the effect of applying a tiny gradient. The more blur applied, the gentler the transition between the colours.

If this same approach worked in sharpening it would be wonderful, but unfortunately it is a totally different thing. Faced with the problem of changing the numerical values of adjoining pixels to make them appear sharper, Photoshop simply compares the values either side of any edge and then darkens the darker value and lightens the lighter one. This is an old dodge used by photographers for many years; it is actually a simple contrast adjustment, but applied to an edge it makes it appear to be more sharply in focus.

There is a problem, however: if you 'sharpen' too much, the device continues to increase contrast at the edges, until ultimately it will become totally pixellated and, at its extreme, change back to its basic default pixel colours. The warning should already be clear – use this tool with great caution and with low percentage strength setting, and if you require considerable sharpening, use the more successful Unsharp Mask filter instead.

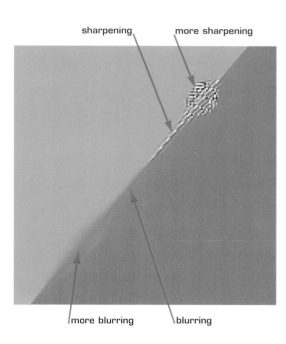

Oversharpening can have disastrous results, to the extent that the image disintegrates into its constituent pixels.

SMUDGE TOOL

This tool makes it possible to pick up pixels in an image and merge them selectively with other parts of the picture. If you imagine this as dragging your finger through wet paint you will have a good idea of how it works.

As you move the brush across the image it picks up the pixel colour beneath it and then puts it back down a little later as a brush stroke. How far it carries the colour before it is released and replaced by the next is determined by the strength set; at 10% it barely moves the pixels, but at 100% it takes the initial pixel colour and smudges it until the mouse is released.

The higher the smudge percentage, the further the colour effect will continue before being replaced by another colour.

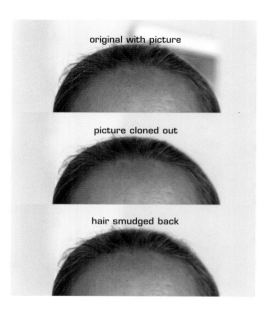

original with picture

picture cloned out

hair smudged back

Selecting and changing areas around hair is always a problem; the Smudge tool is a very effective way of simulating hair replacement!

The uses for the tool are not obvious, other than utilizing it to produce a painted effect, but it is valuable in simulating hair after a person is moved from one photo into another. Clicking in the hair and dragging outwards can leave the impression of flyaway hair, especially after it has been gently blurred. With a little practice, smudging is indistinguishable from the real thing!

DODGE TOOL

The Dodge and Burn tools are Photoshop's attempt at mimicking darkroom practices – and, used with care, they do the job well.

Dodging reproduces a photographic darkroom process for bringing more detail out of the darker parts of a negative. Running the Dodge brush over the image will cause all pixels over which it passes to become lighter. This can be very valuable, but it must be used with care – at its default value the picture lightens dramatically, and although it does not continually increase the effect, as the Blur tool does, it can still quickly look unsightly. Reduce the 'Exposure' to 10% or less and just leave it there; this allows you to gently expose the darker areas, under control, until satisfied with the result.

The ability to select the tonal range of the pixels to be dodged is also of great value. On the options bar, alongside Range, you can choose shadows, midtones or highlights, and if you then move across the image it will have a greater impact on the tone range selected than on the other two.

This may seem a little complex at first, but if you consider a photo of an eye taken without a bright light source, the chances are that it will not show a catchlight within it, which makes the eyes appear lifeless. Lightening the whole eye using midtones would not only lighten the highlight but also the grey areas, and that would not work. Changing to Highlight mode will work much more strongly on the lighter catchlight and produce the desired result.

Dodging using the Airbrush from the options bar softens the whole effect, and is generally to be recommended.

BURN TOOL

This is the other side of the coin and is used to darken parts of an image; all the comments made for the Dodge tool are valid here.

Be warned that although both lightening and darkening only alter the grey values in an image, when burning they can give the impression of deepening the colours as well.

The Burn tool can often complement the Dodge tool. In the example of the eye here, by using Burn in Shadows mode on the darker parts of the image, it can be used to darken the pupil or even to add to the mascara without changing the lighter areas at all.

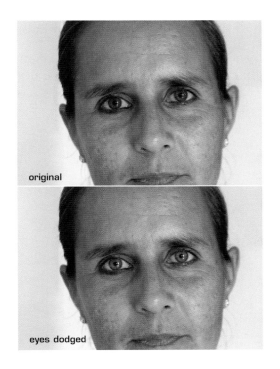

original

eyes dodged

The Dodge tool is ideal for emphasizing the catchlight in an eye, making the portrait look more alive and vibrant.

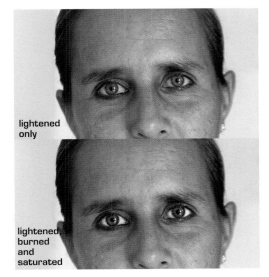

lightened only

lightened, burned and saturated

The dramatic emphasis added to the face, as a result of the use of just three very simple tools, is remarkable.

SPONGE TOOL

This is an unusual one with some valuable attributes if used in the right place. By selection in the options bar, the Sponge tool will work to either saturate or desaturate the image. Saturation will add more of whatever colour is already in the image, making it more strongly coloured. Desaturation has the effect of diluting the colour, ultimately to just grey values.

Selectively adding or subtracting colour in an image can be a powerful tool for emphasizing an object. Colour is a significant feature in any photo, and when juxtaposed against diluted colours, or even no colour at all, it can be extremely commanding and dominant.

In the eye example here, it can be used with great effect to raise the colour of the pupil, adding further strength to the image.

WORKING TOGETHER

Up to this point we have covered a lot of ground fairly rapidly, and it makes sense to try to tie it all together with a working example. This image will be left on my website for you to download and practise on if you do not have a suitable example of your own; go to **Book@barrie-thomas.com**.

This simple image of a house is just a snapshot, and leaves much to be desired. Using only the simple tools mentioned here, we are going to improve it. The problem is clearly seen with the Levels diagram, showing that the image contains similar amounts of dark, mid and light grey tones, it therefore appears to be very flat, and everything in the photo tends to merge together.

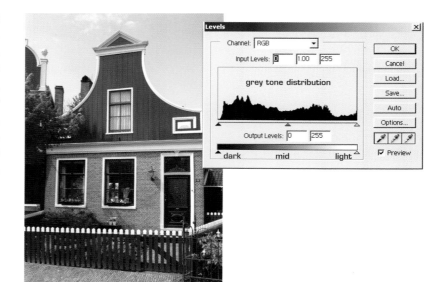

original without any adjustment

I started with the **Dodge** tool, but the order of operation is unimportant – the object was to raise the brightness of any part of the house I wished to emphasize, and included the curtains, white paintwork and downstairs windows and door.

dodged

Using the **Burn** tool, I darkened those areas that were unimportant to the central house. These included the tree and bright white fence to the left, and the unsightly clutter and white fence to the right. The dominant foreground was also darkened to give a stronger base to the image.

burned

The **Sponge** was used in **Saturated** mode to raise the blue colour and to redden the bricks slightly, giving much more warmth to the image and emphasizing the building further. Adding saturated colour to the plants in and below the window also helped.

sponged

focus

Finally, **Sharpen** was used to emphasize the central area, and **Blur** deadened further the edges of the image.

The end result was well worth the effort. To complete, I used the **Rectangular Marquee** tool to select the inner area and then inverted the selection. Using **Image Adjust Hue/Saturation**, I then moved the Lightness lever to the right to 'fade' the outer edges and complete the frame.

finished

Cloning and healing
ONE OF THE MOST POWERFUL FEATURES WITHIN PHOTOSHOP IS THE ABILITY TO TAKE PARTS OF A PHOTO AND THEN PLACE THEM ELSEWHERE, EFFECTIVELY CLONING FROM ONE AREA TO ANOTHER. THIS CHAPTER DEALS WITH BASIC TOOLS FOUND IN THE TOOLBOX, THE CLONE STAMP, HEALING BRUSH AND PATCH.

CLONE STAMP TOOL

Rarely given its full name, the Clone tool is marked as a rubber stamp in the toolbox and should not be confused with the Pattern Stamp tool, which uses a similar icon but is totally different.

The basic idea is to tell Photoshop where you want the pixels collected from and then where you want them placed. To pick up the pixels, first press the Alt key (Option key on the Mac) and click in the image to determine a source point; once clicked, the mouse button is released. Moving to another point now without clicking en route, retains this information, and as soon as you begin to paint again, the pixels from the source point are painted over the pixels in this new position.

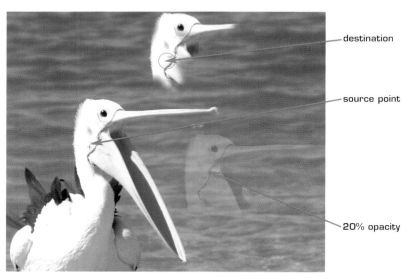

The Clone tool reproduces the selected part of the image elsewhere in the same image, or into a separate image.

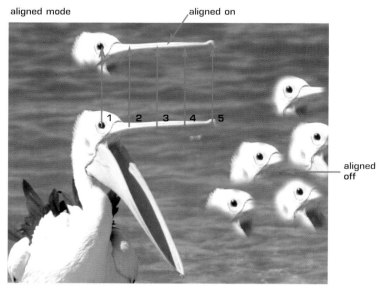

In Aligned mode the relationship between the source and destination points is a constant; with Aligned off, the clone will restart from the original source point every time, creating multiple copies.

Brush size, Blending modes, Opacity and Flow all work in much the same way as for any other brush. Use All Layers picks up from any of the layers in the stack and places the gathered pixels onto the active layer on which you are working.

Aligned is an interesting option. When it is selected the relationship between the source point and the destination, once set, does not change; it is as if the two positions were locked together by a fixed connection – if one is moved, the other moves along a parallel path. When working in Aligned mode if you are interrupted it doesn't matter, you can carry on working and the brush will continue to paint as before, carrying on the image clone seamlessly, as if you had never stopped.

With the alignment box unchecked this constant link is broken, and every time you stop and then restart painting with the Clone tool, it will again place the pixels from the original source position, repeating the information painted previously.

The Clone tool is used in many different circumstances, but perhaps the best known is as a means of removing unwanted items from within an image, like the out-of-focus gull and the beak of a second bird in the pelican photo at right.

Clicking on the sand and moving in towards the gull from both directions fills that area with new cloned sand pixels and removes the gull. The pixels used to replace the beak were taken from the area to the right of the bird, where the colouration is very similar.

Beware of cloning from the same source point for too long. The original image is retained in Photoshop's memory, and if you pass over a significant change in the original image, even if it is no longer visible on screen, this can create problems. It is also considered good practice to keep changing your source point to avoid getting readily identifiable patterns, which the eye is particularly good at discerning.

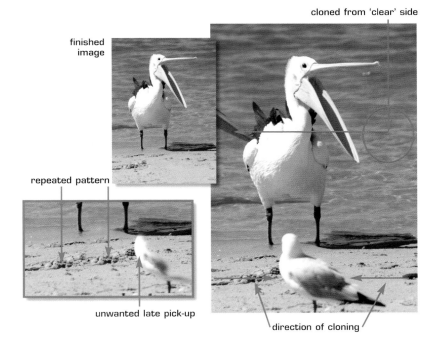

Unwanted areas of the photo were removed by carefully sampling similar areas, with the Clone tool, and then repainting them where needed.

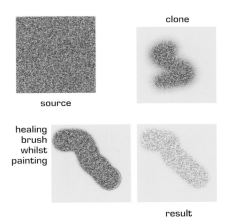

This is an artificial case and would not be attempted in reality, but it clearly shows how the Healing Brush reconstructs the paint stroke into the colours of the receiving end.

HEALING BRUSH TOOL

Unlike the basic Clone tool, this does not take the entire content from the source point and then place it elsewhere; instead, it places the source data into the new position, and alters it to take account of the texture, lighting and shading.

Activation is very similar to the Clone tool. First click on a source point with the Alt key held down and then release the mouse over that spot, then move to the position that you want to alter and start painting. Don't panic when you see the application of the new strokes – at first they are fully the colour and texture of the original, and it is only after you release the mouse button that they 'heal' and merge into the new position.

Clicking the Brush Size icon on the options bar does not reveal the normal brush selection, but accesses the Brush Design palette, allowing you to construct whatever brush you require. Diameter is the spread of the brush stroke; Hardness determines whether it is to be hard-edged or have soft, anti-aliased edges, and Spacing is how frequently strokes are applied to the canvas.

The source from which you work can be chosen directly from the image or from any of the patterns that are available. Either way the result will be based around that particular texture and lighting effect.

The Healing Brush is a superb tool, but it does take a little practice to get it right. Avoid any edges because they will produce a smudged effect at the finish point, and don't be too casual about your source point just because you know that it is possible to adjust it anyway. It still pays to choose your source with care – and saves considerable cleaning-up afterwards.

Practically speaking, it is best to use the Clone tool and the Healing Brush together, switching between them according to which is able to complete the task most effectively at that point in the image.

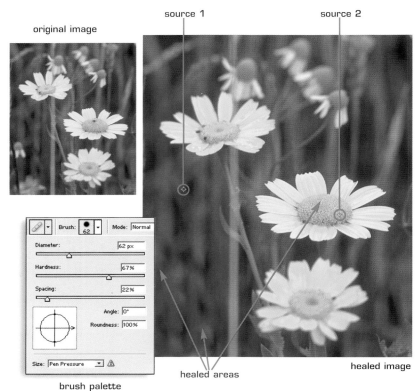

With the Healing Brush a seamless 'repair' of the image is possible, using just two source points.

PATCH TOOL

This is another very clever device, used for repairing or replacing large parts of an image. It works by transferring a selected part of the image to another position simply by dragging, and then merging one into the other.

Before you start using it, take note of the source and destination buttons on the options bar. In the default source position it can be confusing because, unlike the other clone devices, you select the 'damaged' area first and then drag it away to a position where there is no damage. This is a little awkward in practice and my advice is to turn it the other way around by using destination; this is the method described here.

After selecting the Patch tool, drag around the undamaged area that you wish to use for the repair; on releasing the button you have made a selection. Moving inside that selection changes the appearance of the cursor, and it is now possible to drag the selected area anywhere within the image by holding the mouse button down and pulling.

When located over the area to be repaired, the mouse button is released and the patch will totally replace the area beneath it. Photoshop will attempt to seamlessly merge the edges with the original pixels.

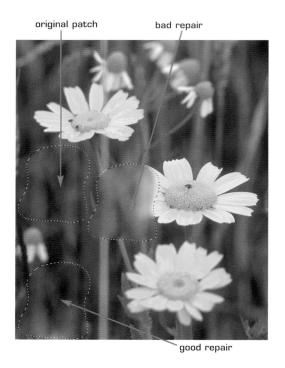

Although the Patch tool works well, and is useful for repairing large areas, it can handle edges very badly. Check carefully after any repair is made with it.

Patch is an effective tool, but it does have its limitations. When dealing with clouds and similar soft-edged, abstract shapes, it is near perfect, but in a complex multi-coloured image it can struggle a little, so use it with caution. It pays to work with small rather than large areas, and to select with care.

Selections can be made with the Line Select tools if preferred, and you can then move on to the Patch tool when satisfied with the result. Even when using the Patch tool, selections can still be altered. Add to them by holding down the shift key and selecting the new pixels to be added, or press the Alt key (Option key on the Mac) before removing an area from the selection already in place.

The effect of using these three tools together can be dramatic, and they allow easy removal and replacement of objects seamlessly. Perhaps the best-known application is in retouching old or damaged photos, as in the example here.

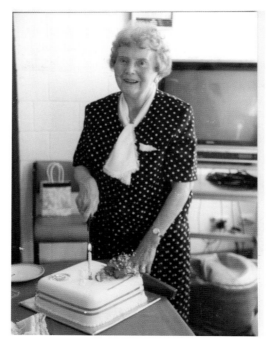

Household clutter mars this photograph, but a little work with the Clone, Healing and Patch tools can straighten it out.

The original photo belonged to a friend and was irreplaceable, but unfortunately had been taken with a less than glamorous background. Using all the tools here, the clutter was selectively removed before gently blurring the background to achieve the desired effect. This is not necessarily a quick 'fix', since it is a very time-consuming process, but it can be very satisfying and is always well received.

These tools are immensely powerful, and time spent learning how to use them properly will be repaid over and over again.

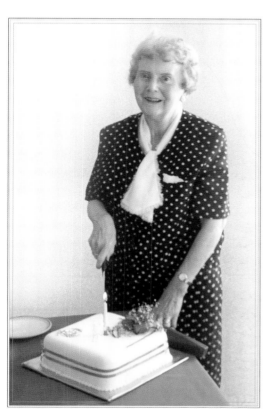

The finished image with all unnecessary items removed and a simple border added.

Line selections

PEN TOOL

This is a confusing tool because of its many variations. In the hands of an expert graphic designer it looks ridiculously easy, but newcomers to Photoshop often have difficulty. I'm not going to attempt to cover all the many possibilities here – there isn't enough space – but am simply going to provide the necessary information to make the tool usable.

To understand how it works, click on the icon marked Paths on the options bar (the name appears if you hold the cursor over the top of the icon for a short while) and then select the Pen tool from the toolbox.

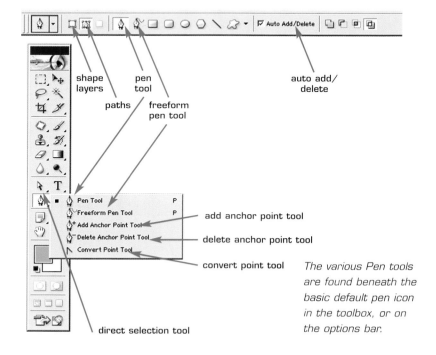

The various Pen tools are found beneath the basic default pen icon in the toolbox, or on the options bar.

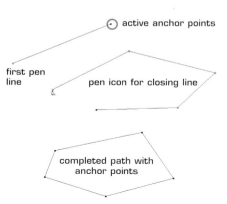

Simple paths, constructed using a series of points with straight lines connecting them.

Clicking within an open Photoshop document now places a square dot on the image, known as an anchor point, which is filled with grey; clicking again in another place will join the two dots with a line, and again the active dot is filled with grey. Every time a dot is placed more lines are constructed, and this will continue until the image is double-clicked – two quick clicks in succession – or until the mouse cursor is clicked again over the original square, and a pen nib and circle appear. Either of these will cause the two ends to connect, and at that stage a 'path' has been created.

This is clearly ideal for selecting anything that is composed of straight lines, no matter how complex, especially when used in conjunction with the Zoom tool, but what about curved lines?

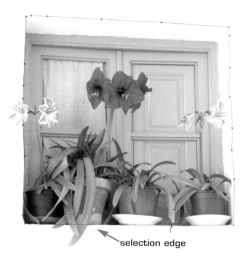

A simple straight-line selection with the Pen tool allows considerable flexibility.

Curves are just as easy. This time click the mouse over the image where you wish to begin, but instead of leaving it motionless, drag it across the image with the mouse button depressed. The result is a square dot as before, but this time with handles on either side of it. Now place another dot in the same way, and the line between the two is curved. It's a good idea to pause here and have a good 'play' before starting a project, to get the feel of the straight and the curved lines that result from using the mouse in these two different ways.

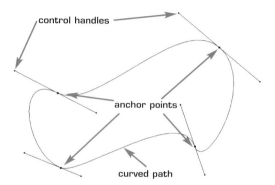

Vector curves and the associated controls, drawn by clicking and dragging the mouse across the image.

It is possible to add straight or curved lines wherever you wish, and even to change your minds afterwards. If the anchor point should be a curved one, or is already curved but should be straight, click on it with the Convert Point tool, tucked away with the Pen tool, and it will change.

If there are not enough points to form the shape required, others can be added by clicking on the line with the Add Anchor Point tool, again found with the other pen tools in the toolbox. Removing points is possible using the Delete Anchor Point tool, but a much easier way to do this, worth getting used to, is to simply leave the Auto Add/Delete switch within the options bar checked and then simply click on the line to add a point, or click on a point to delete it. It is a good idea to get into the habit of using the minimum number of points necessary to enclose the shape required – too many makes it more difficult to form the curves.

The anchor points are not fixed; they can be moved and readjusted using the Direct Selection tool, one of the two arrow icons in the toolbox. With this it is possible to click and drag on any line in the path to move the whole thing, or to click on any point to reactivate the control handles.

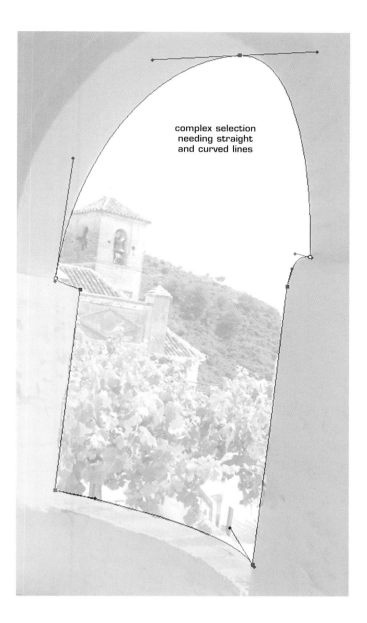

complex selection needing straight and curved lines

A complex shape of curves and lines is easily and accurately enclosed with just a few anchor points.

CONTROL HANDLES

Now for some fun! If you haven't tried using control handles before, prepare to be amused – or frustrated – as they take getting used to.

If you cannot see the handles, click on the anchor point to reactivate them. Now, using the direct select arrow, click on the square at the end of the control handle and move it. Isn't that fun!

Basically, the rules are as follows:

• The nearer the handle is to its own anchor, the flatter the curve will be on that side of the anchor point; conversely, the more it is pulled away from it, the greater the curve.

• Points at either end of a line work together to form the curve between them, and both normally need adjustment.

• If both are pulled away from their anchors in the same direction, the curve will be a simple one and become more acute as the handles are pulled nearer to each other, and further away from the anchor points.

• If one handle is dragged in the opposite direction to the other, the curve will be a complex 'S' shape.

• If both handles are pulled back over their respective anchor points, the line between them will become straight.

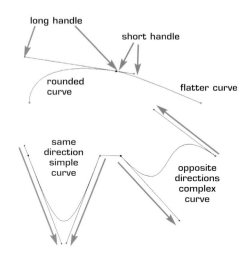

Pulling the control handles at any point changes the shape of the accompanying curve.

poor selection using larger brush

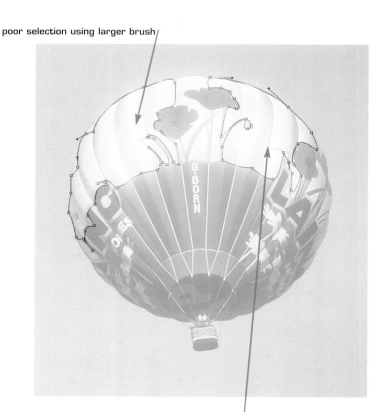

better selection with small brush

FREEFORM PEN TOOL

This one attempts to do it all for you! Select it from the same place in the toolbox as the other Pen tools and simply draw freehand around the shape; as you do so, Photoshop inserts the necessary anchor points. If it turns out to be unsatisfactory then you move, add or remove in the same way as outlined on pages 66 and 67. This works very well, and it's worth spending time getting used to it.

There is also a Magnetic option within Freeform, activated from the options bar, which will try to identify any edge as you move across the image. This is not always perfect, but the secret is to use a small brush, and only try to select the more clearly defined edges within the image.

The Magnetic option is only available from within Freeform and works best when using a small brush.

OTHER OPTIONS

There are many other possibilities. If the Shape Layers icon is activated instead of paths, as you draw the shape will automatically fill with the foreground colour. This is a little like the Magnetic Lasso tool, and works even more efficiently because it is relatively easy to reposition any lines that were incorrectly placed initially.

Another fun aspect of Shape Layers is the opportunity to fill any construction with a pattern. Before drawing the path it is necessary to activate the Shape Layers icon on the toolbar and select a pattern via the Style button. Now as you draw, the enclosed shape will automatically fill with the chosen pattern, and can be subsequently reshaped at will.

PATHS AND SELECTIONS

The end product is a path; this can be viewed by opening the Paths palette from within the Window menu in Photoshop.

The icons along the base of this palette allow you to fill the image with colour, place colour along the path as a stroke, and turn the path into a selection or, if a selection is already in place, convert that selection into a path.

For the photographer, the opportunity to work on the image with vectors and then convert it into a selection to apply the shape to a bitmap image, is a very valuable resource. Paths and vectors are largely the province of graphic designers rather than photographers, but if there is a regular geometric shape within your image, this may well be the best way to select it.

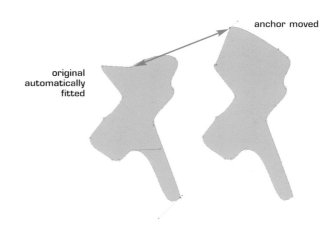

anchor moved

original automatically fitted

Shape Layers are filled automatically, and continue to be, even if the outer shape is changed.

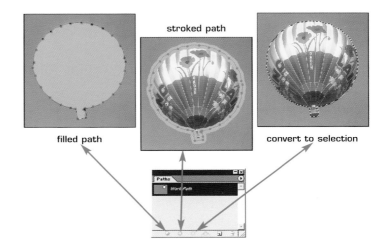

stroked path

filled path

convert to selection

Professional designers work with paths extensively, but unless working with graphic shapes regularly, they are less important to the photographic user.

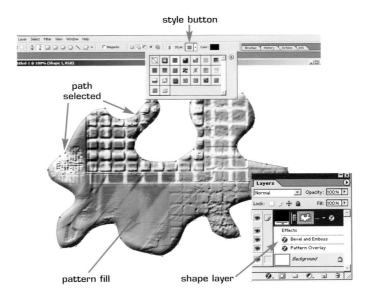

style button

path selected

pattern fill

shape layer

If a pattern style has been selected, as soon as an area is enclosed it will automatically fill with that pattern.

Vector tools

SHAPE TOOLS

The Shape tools can be accessed from the options bar if the Pen tool is selected, or by clicking on the icon alongside the Pen tool. There are five basic choices: rectangle, rounded rectangle, ellipse, polygon or custom. The Line tool is also included within this selection.

Whichever of these is chosen, the mode of operation is very similar, in that after the shape is formed by clicking and dragging, it automatically fills with a selected colour – the foreground colour by default – or fills with a 'style' if one is selected.

Shapes behave in the same way as any other vector item, in that they can be resized upwards or downwards without any loss of quality. They also have paths attached to them and can therefore be reshaped if they are not exactly as required. Clicking the shape outline with the Direct Selection arrow reactivates the control handles; pulling on any of these handles will move that point and change the shape of the path. The extended reformed shape will again fill automatically with whatever colour was already within the area.

Apart from the addition of a radius value for the rounded rectangle, to control the curved edges, and a number of sides option for the polygon, the options bar for the Shape tools is the same as that for the Pen tool.

The final shape can be a combination of any of the basic ones, and is made by simply adding or subtracting new shapes using any of the tools. The add, subtract and intersect buttons on the options bar work in exactly the same way as they do for normal selections.

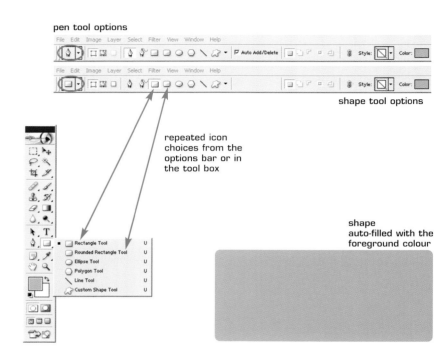

The many complex choices relating to the shape tools can be accessed directly from the toolbox, or from the Options bar if the Pen tool or Shape tools are active.

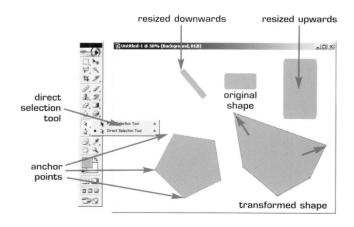

Once formed, shapes are automatically filled; the shape can be changed by pulling on a control handle with the Direct Selection tool.

Vector-based shapes do not happily co-exist with Photoshop's bitmap format, and for this reason they appear on a separate layer in the Layers palette. This palette is to be found with the other palettes under the Window menu. If a shape layer is 'flattened' it will be rasterized (turned into a bitmap image) and individual edges will no longer be editable.

Double-clicking directly upon the coloured area on the shape layer accesses the Color Picker, allowing any colour to be selected. The chosen colour will automatically replace the fill colour that is already in place.

Custom Shape is the odd one out, and enables a choice of the shape required from a drop-down palette on the options bar (see page 72). The default options list is short, but many more may be obtained via the arrow at the top of the box. These shapes, like any other, have their own specific colour layer that can be recoloured in a multitude of ways. Shapes can be edited indefinitely until they are finally rasterized.

The Line tool is also tucked away with the shapes, and enables lines of any length, direction or thickness to be drawn. By using the small arrow alongside the shape icons on the options bar, it is possible to design and add arrowheads to the line.

composite

exploded view

A simple graphic constructed using a few of the basic shapes that are available within Photoshop.

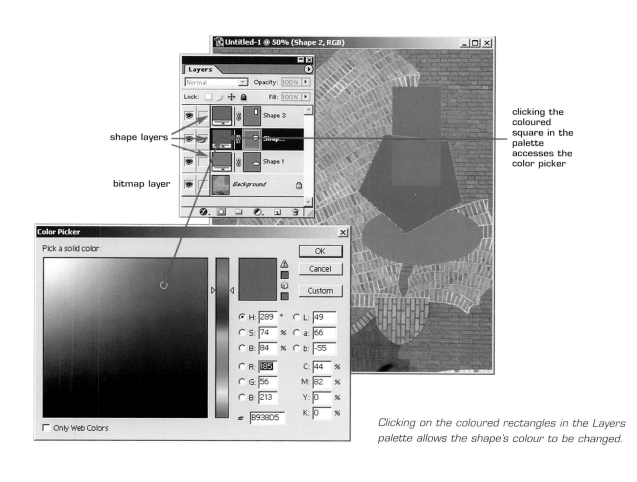

shape layers

bitmap layer

clicking the coloured square in the palette accesses the color picker

Clicking on the coloured rectangles in the Layers palette allows the shape's colour to be changed.

access arrow

drop-down palette

additional shapes

TYPE TOOL

The Type tool is a very specialized, but immensely valuable, vector tool. Within the type button on the toolbox there are four options available: two are not vector-based and produce masks/selections based around bitmaps, and two are much more powerful vector-based devices.

After selecting one of the Type Mask tools from the toolbox and clicking within the image, the whole area will be covered in a pink mask. As you type, the letters will effectively cut holes into this mask, and when you deselect the Type tool, these clear areas will become selections that take on the shape of the letters.

Many and varied graphic designs are available within the Custom Shape picker; others may be added from the list accessed via the palette.

From here they behave like any other selection and can be filled, stroked etc. The one big problem, of course, is that if you resize or reshape them, the crisp edges of the selection that define the type will become blurred and less satisfactory. Vector type, however, can be resized and reshaped indefinitely because the shape is defined by calculation, and therefore can be easily redrawn by a computer to different dimensions.

The procedure is much like any word-processing package: click in the image and a text cursor bar will appear where the first letter is to be placed. Type normally, and each letter will be positioned and coloured according to the colour swatch in the options bar. If a different colour is needed, the choice can be made by clicking on this swatch.

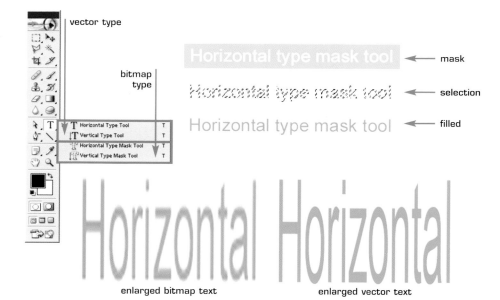

vector type

bitmap type

Horizontal type mask tool ← mask

Horizontal type mask tool ← selection

Horizontal type mask tool ← filled

Vector type can be enlarged freely, without damage to the edges, whereas bitmap type deteriorates badly when resized.

enlarged bitmap text

enlarged vector text

Typeface, text size and other text attributes can be chosen in advance from the selection on the options bar, but in reality doing so in this order matters very little, because they can all be changed afterwards anyway.

You can type anything however you wish, and still end up with it looking good and with the most amazing effects attached to it. Apart from the obvious text attributes, there are a number of basic alignment options and many more specific options within the Character and Paragraph palettes. These can be accessed in the normal way via the Window drop-down menu, but when using the Type tool, there is a small page icon within the options bar that is more readily accessible. To re-activate the text, either sweep across it with the mouse with the text tool selected, or click the 'T' on that layer in the Layers palette.

This has brought us to the crux of vector usage, and the Type tool is the finest example of the possibilities. As far as Photoshop is concerned, all you are doing is 'playing' with a geometric shape, so you can do anything with it!

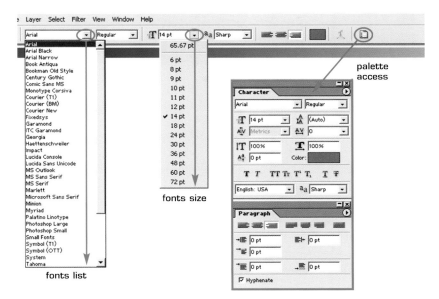

palette access

fonts list

fonts size

Fonts available for use with the text tool are different for every computer. Additional font sets can be purchased or downloaded over the Web.

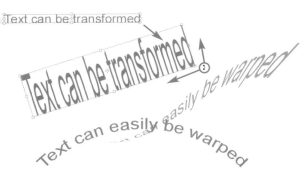

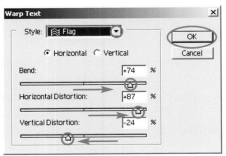

warped text dialogue box

If you ensure that you are on the correct type layer and then choose Edit > Free Transform from the drop-down menus, the type will be enclosed by a resize box. Pulling on any of the handles, or even moving outside of a corner with the mouse and rotating the selection, reshapes the letters and appears to damage the letter edges, but, as soon as you click OK, Photoshop magically reconstructs it all perfectly.

As if this were not enough, you also have the option, via the Create Warped Text icon on the options bar, to curve your text. Using the Style field you can twist and warp it in many different ways.

Finally, at the base of the Layers palette there is the usual option of applying a layer style to your text. These layers will be looked at later, but for now just try clicking on some of them while on a text layer, and prepare to be staggered by the number of effects that are possible!

Photoshop's text effects are amazing. It is possible to twist and distort any text whilst retaining undamaged sharp edges from the original.

Info tools

ADDING MESSAGES

This is a fun one! Supposing that you wished to send a favourite photo to a friend and tell them about the circumstances surrounding it; well, here's the chance to do so. There are two options: to send it as a written note, or as a sound attachment.

Notes tool

The Notes tool, along with other related tools, sits just above the Hand tool in the toolbox. Clicking on the Paper icon and then on the image sets the point at which the note will be placed. As you click the note will automatically open, allowing normal text entry into the box. The message typed will then be transmitted with the image whenever it is passed on to someone else.

On the options bar it is possible to change the title line, the name of the author, the font used and also the colour of the note.

Audio Annotation tool

This is very similar to the Note tool, except that the message is transmitted as a sound file. A microphone is required to enable you to record the outgoing message.

Clicking on the image places a speaker icon, and a box opens inviting you to start the recording. When completed the recording is stopped, but the message as recorded remains attached to the image. When received and opened in Photoshop, it can be read on-screen or heard via speakers, depending on which method is used.

notes

audio annotation

The ability to attach notes, or even audio, to an image can be extremely useful, provided that the person receiving it also has access to Photoshop.

IDENTIFYING COLOUR

The Eyedropper Tool is a clever and useful device that facilitates colour identification within Photoshop. The basic Eyedropper allows accurate selection of any screen colour, simply by placing the cursor over that point and clicking (see opposite). The precise colour selected instantly appears within the foreground colour palette and is ready for use elsewhere. Clicking on a colour while holding down the Alt key places it into the background colour position in the toolbox.

One of the problems with this type of colour selection is that it can be too specific: if you click on a scanned dust spot on the image you could get a false reading of the colour in that area. To counter this Adobe provides opportunities, using Sample Size from the options bar, to spread the area of selected colour to more than one pixel. 3 x 3 will average out the eight pixels arranged around the centre one, whereas 5 x 5 will move the sampling out a further pixel before calculating the average colour contained within all of them.

A single click within the exhaust from the jet was used to define the colour of the border keyline.

keyline colour sampled from jet exhaust

5 x 5 sampling

3 x 3 sampling

Selecting with the Eyedropper can be particularly valuable when trying to match the colour of items within an image, within different images, or when choosing colours from a photo to use as borders, or as the text colour.

You may want more than just a transfer of the colour to a box; in this case,you need to know the actual pixel values for that particular point, so that they can be identified again. Other Photoshop users, such as scientists or print workers, routinely need to identify colour values as a part of their daily work. To assist with this, Photoshop also provides an Info palette, which takes the functionality of the eyedropper to another level.

selection point

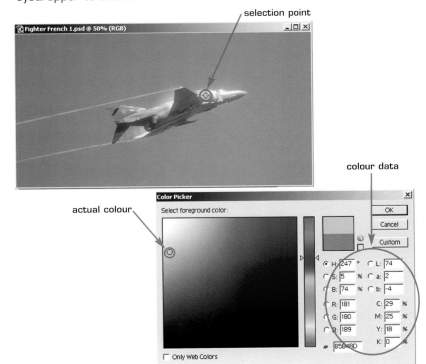

colour data

actual colour

When the Color Picker is open on-screen, clicking anywhere within an image will precisely identify the colour at that point, and give its associated numerical values.

THE INFO PALETTE

If the palette is not already visible on-screen, click on the Window menu and then onto Info to open it. The palette is divided into four sections by default: the upper two are colour identification areas for the most used colour spaces, RGB and CMYK, and the lower sections are for positional information and dimensions. These are not the only possibilities since via the Palette options, located under the arrow in the top corner of the dialogue box, the readouts can be changed to display most of the colour modes.

When the info box is displayed, simply move the mouse pointer across the image to activate the colour and positional information. What actually happens is that the cursor point is identified and recorded, using conventional X (horizontal) and Y (vertical) co-ordinates, using whatever values are set. These values too can be changed via options. Having identified the point Photoshop then identifies the colour values at that position, depending on the size of the sample requested.

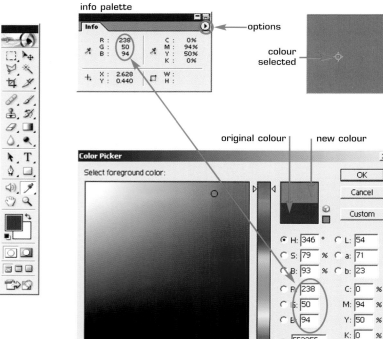

The numerical information for any identified point in the image is the same, whether read from the Info palette or from the Color Picker.

The numbers are the normal RGB or CMYK values, and if the Color Picker is also open, they are of course exactly the same values that are recorded there.

Hidden away beneath the Eyedropper tool is the related Color Sampler tool, an even more sophisticated way of assessing colour accurately. When this tool is active it is possible to record information from several parts of the image and retain them all on-screen at the same time. The first click extends the Info box and gives the required colour information in whatever mode you wish; the second click, instead of replacing this data, simply adds another box to it, and so it continues for up to four samples. If you decide the sample points are no longer needed, they can just be dragged off the image area with the cursor, and new ones can be created as required – they can even be repositioned by being dragged to another point in the image, and the values for that point will then redraw.

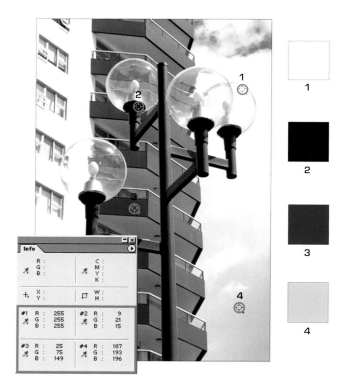

The Color Sampler tool allows sampling of the image in four separate places and retains the information for each point sampled.

MEASURE TOOL

The final tool contained within the Eyedropper set in the toolbox is the Measure tool. This alters the appearance of the Info palette, and the space normally used by the CMYK colour information is replaced with angular data.

If the need arises to measure distances or angular displacement within an image, this is the tool to use. Click at the start of the line and drag with the mouse button depressed to the finish point; the line will be visible on screen, but more importantly, its precise position, length and angle will be measured. The information given is:

X The start position.

Y The end position.

W The horizontal displacement of the finish, from the start point, as a positive or negative value.

H The vertical displacement of the finish, from the start point, as a positive or negative value.

A The angular movement from the horizontal, between 0 and 180°; positive values are above the line and negative below it.

D The distance from start to finish in a straight line.

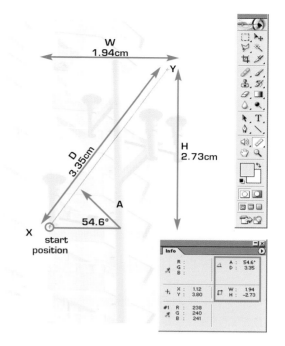

The Measure tool is an extremely accurate way to obtain geometric information about any line drawn.

original 60° selected area

multiple selections cut and pasted together

A complex kaleidoscope pattern created using information from the Info palette.

As a photographer you may now be wondering when you would ever use any of this information but it's amazing how often it seems to occur. As an example, consider the possibility of creating a kaleidoscope-type pattern from one of your photos.

To do this you would need to be able to make a selection that had fixed angular displacement which could be totally controlled. For six segments it would need an initial selection of exactly 60° if they were to fit perfectly without any gaps (360° divided by 6 = 60°).

Using the Line Drawing tool and watching the Info palette, which changes slightly when this tool is selected, it is possible to draw a segment with 60° angles and then turn it into a selection with the Magic Wand tool, before superimposing part of a photograph into it using 'Paste into'. Simple manipulation of the shape once created, using the transform controls, allows you to create a kaleidoscopic pattern that fits exactly.

Magnification

ONE OF THE GREAT STRENGTHS OF IMAGE EDITING IN PHOTOSHOP WHEN COMPARED WITH CONVENTIONAL PHOTOGRAPHY IS THE ABILITY TO EXPAND THE IMAGE. IT IS POSSIBLE TO WORK ON A HIGHLY MAGNIFIED PORTION OF THE IMAGE, GIVING VERY FINE CONTROL, AND THEN ZOOM BACK OUT.

NAVIGATOR

Navigator is a clever magnification device. Although it is found among the palettes, It has been included here with the tools because it duplicates much of the work of the Zoom tool.

If the palette is not visible on your screen, don't worry – it is tucked away with all the other palettes in the Window menu. Simply click on it and it will reappear in the place where you last left it. Within the palette is a small thumbnail view of the active image, which contains a red rectangle depicting the area of the photo that is actually visible on the screen. When you click and drag on this rectangle it moves with you and different parts of the image can be seen as you move over them; in this way you 'navigate' around the image. It's a little like viewing a magnified section of your image through a rectangular magnifying glass.

It is also possible to zoom in or out of the selected area within the rectangle. Click and move the small triangle on the line beneath the thumbnail photo to increase or decrease the magnification of the picture seamlessly; click on the small triangles at either end of the line to zoom by fixed amounts. The zoom magnification relative to the original is shown in the percentage box, and this figure is repeated in the title bar of your image and also in the lower left corner of the screen.

The small red rectangle within Navigator shows the section of the image magnified on-screen

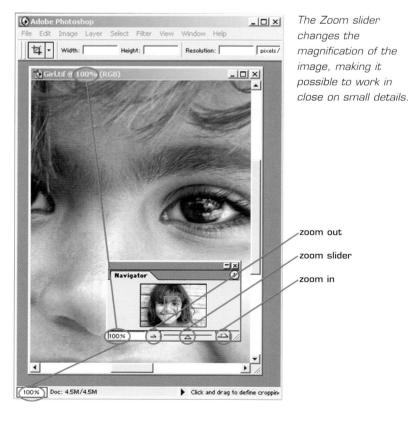

zoom out

zoom slider

zoom in

The Zoom slider changes the magnification of the image, making it possible to work in close on small details.

percentage magnification

The default red rectangle in Navigator would be almost unusable on a mainly red image; to overcome this, the colour of the rectangle can be changed by clicking the arrow in the top right corner of the palette and selecting Palette Options.

ZOOM TOOL

The Zoom tool, which is found near the base of the toolbox, is very easy to use. Click on any image with this tool selected and it will magnify it; click again and it will magnify it further.

Magnification at 100% is set to screen resolution, which means that if you were to set the pixel dimensions of a new image to the same values as those used for your monitor screen, and then magnified the image to 100% within Photoshop, it would exactly fill the whole screen area. Don't worry if that didn't make sense – the important thing to realize is that your image can never look any better than this on the screen, and that is why it is always a good idea to check your final adjustments to any picture, at a magnification of 100%, before saving or printing it. Any obvious errors at this magnification will almost certainly be visible on the finished print.

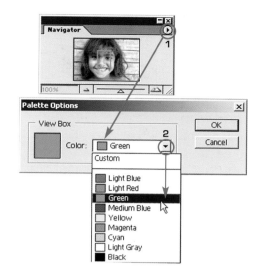

To facilitate working on an image that is already mainly red, the default rectangle can be changed to other colours.

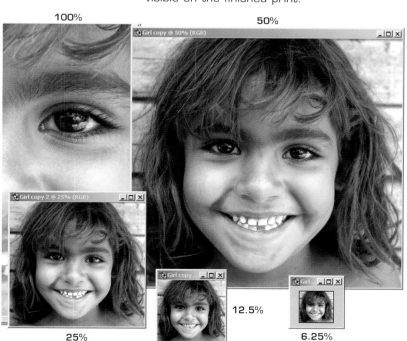

100%

50%

25%

12.5%

6.25%

Percentage zooms downwards from 100%. Many other magnifications are possible, and any suitable one for the job in hand may be chosen.

Magnification over 100% is not a good idea, unless it is a working device to allow you to see that area more clearly. Any value over 100% will cause your image to break up, and the pixels from which the picture is constructed will become visible as it becomes larger. Maximum magnification for viewing is 1600%.

Take care when viewing an image at 'odd' intermediate figures, such as 33.3% or 66.6%. These are asking Photoshop to do the impossible and display a full pixel at one third or two-thirds its actual size – it will display the result, but the image at these intermediate values is always very irregular on-screen, and marked pixellation will be visible. The good news is that this is only a screen thing, and all will return to normal when the image is resized or printed.

Zooming in is a simple matter of clicking inside the image, whereas zooming out requires a keystroke as well. Pressing the Alt key while using the Zoom tool changes the symbol inside the magnifying glass icon from a + to a – and as long as the key is held down, every click of the mouse zooms back out. Another way to achieve the same thing is to use the plus and minus symbols on the Options bar. If you click on a particular point in the image, Photoshop will centralize that point after it has been zoomed, unless it is too close to the frame.

The window surrounding the image is normally a fixed size, and therefore as you zoom out the photo will get smaller and smaller within it, while the surrounding box remains unchanged. Conversely, if you zoom into the image, less and less of the photo will be seen within the window. This is not necessarily the best way to work, since there is little point in having much of your screen covered in a neutral grey colour. Clicking on Resize Windows To Fit in the options bar causes the whole window to resize as well as the photo, thus keeping your desktop tidy.

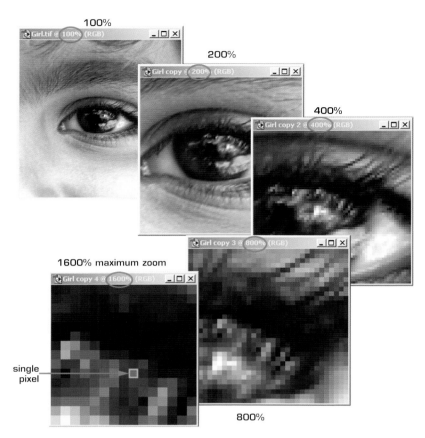

Overmagnification will make the pixels visible and should be avoided where possible. It becomes very difficult to make accurate changes to the image if the picture is over enlarged.

Zooming on a specific point will place that part of the image centrally within the next window, unless it is too close to the edge.

On the options bar there are three
additional buttons:

Actual Pixels This creates an instant
zoom to 100% and therefore the
best on-screen view that is possible.

Fit On Screen This will make the image
fill the screen area as far as possible,
while still allowing you to view the
entire image.

Print Size This uses the figures in the
Image Size dialogue box to show the
image at the size it would appear if it
were printed.

These controls, together with the zoom in
and zoom out options, are also available by
right-clicking the mouse when it is positioned
over the image, and using the menu that
then appears.

USING THE KEYBOARD

There are times when it is awkward to leave
what you are doing and go to the toolbox.
Zooming is an action so frequently required
that many digital workers prefer to control
the whole thing from the keyboard, without
using the toolbox at all, and this is a
technique well worth acquiring. Regardless
of the tool being used, pressing and holding
down Ctrl and Alt together on the keyboard,
and then using the plus and minus keys to
zoom the image, is all that is required.

When there is insufficient room on screen
it is sometimes difficult to work within a
window where only a small part of the image
can be seen; one solution is to activate
Navigator, but this can cause more on-
screen congestion. A better solution is to
press the space bar; this automatically
activates the Hand tool, allowing you to
'push' the image around within its window
using the mouse. As soon as the Hand tool
is released, you return automatically to the
tool you were using previously.

zoom out

zoom in

*resize
windows
to fit*

*When 'Resize windows to fit' is checked, the
entire window will resize when the image is
expanded or contracted. This is an efficient
way to work.*

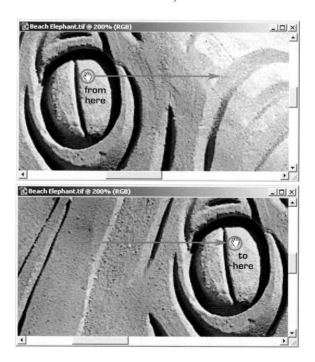

*Pulling and pushing with the Hand tool, easily
activated using the space bar, moves the image
within the window.*

PALETTES

Layers

WE HAVE COME A VERY LONG WAY WITHOUT FULLY DISCUSSING LAYERS, ONE OF THE MOST POWERFUL IMAGE-EDITING DEVICES WITHIN PHOTOSHOP. USERS FREQUENTLY HAVE GREAT DIFFICULTY IN UNDERSTANDING LAYERS, SO I AM GOING TO TAKE IT RIGHT FROM THE BASICS.

LAYER BASICS

Imagine a transparent sheet of plastic being placed on top of a photograph and then viewed from above; you can see straight through the plastic, and there is no indication that it is there at all – what you see is the image underneath.

What has been created is a layer above the image, which is invisible because there is nothing on it. Now imagine that a second image, smaller than the first, is placed on this transparent layer; you can now see the original image through those parts that are still transparent, but where the new image covers the one underneath, you see only the image on the top layer.

The image seen from above has now apparently changed in appearance, but actually you have not altered it at all, merely placed another picture on top, partially obscuring it. This is the key to understanding Layers – it is the concept of being able to stack images above each other and allow parts of one to obscure the others, without actually altering any of the original information.

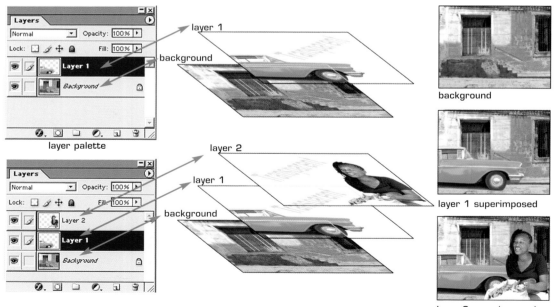

layer palette

To understand Layers it is best to visualize a stack of separate images, each on a transparent background. As one is placed on top of the other, it is possible to see the lower ones through the clear portions of the layers placed above.

background

layer 1 superimposed

layer 2 superimposed

Now take this a stage further and imagine that you have not one but several layers, each one controlling the appearance of a part of the visible image; any of them can still be altered at will, whatever their position within the stack. This becomes a very powerful device, because not only are you able to control tone, colour, focus etc. on each separate layer but you can also reposition the individual elements, either on the same layer or within the stack.

This is just a basic introduction to Layers, but already it should be clear what a powerhouse there is here. As if all this were not enough, you are also able to control opacity of the individual layers relative to each other, blend them together in numerous ways, adjust them without altering the original, change their style and use masking devices to avoid making mistakes that are irretrievable.

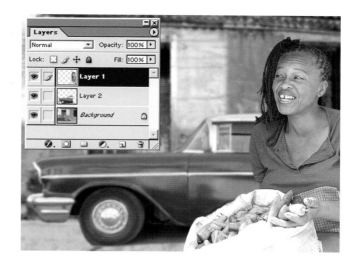

The completed image as it appears after making alterations to the individual layers. Although the separate layers are still in place, the on-screen view does not show them other than in the Layers palette.

MAKING AND MOVING LAYERS

Via the Layer menu on the options bar it is possible to either create a new layer or make a copy of an existing one; there are then a number of other options once these items are clicked. The easiest way is to simply click on the small page icon at the base of the palette, which automatically forms a new blank layer, or to click and drag any layer and pull it onto the page icon to make a copy of that layer. Whether it is a new or copied layer, if you also press the Alt (Option) key as you drag, you will activate the dialogue box for that layer, allowing you to name it and set attributes.

Layers also form automatically when you cut or copy and paste items; or they can be dragged from one image into another, using the Move tool.

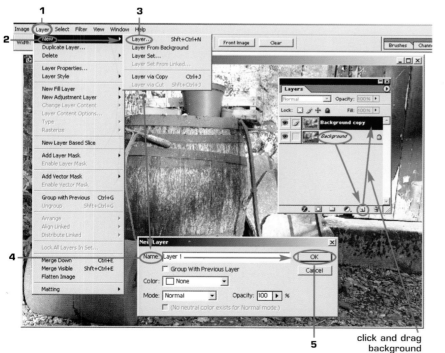

There are a number of ways to make new layers. Following the numbered sequence here, or simply clicking the page icon at the base of the palette, are effective methods.

The new layer will appear above the selected layer in the stack, but it can be repositioned by being clicked and dragged to the place in the stack where you want it to be. As you move this layer over the line between any two layers, that line visibly thickens, and if the mouse button is now released the layer will be repositioned to this point.

The first layer, known as the background, is different from the rest, and not all the functions of a 'normal' layer can be applied to it. If you want to move it or make it behave like all the rest, double-click the name in the Layers palette and convert it.

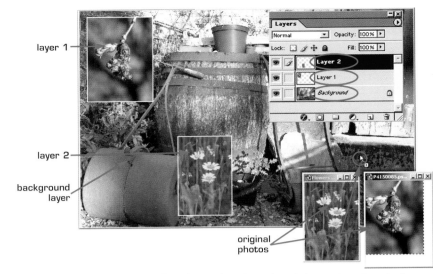

layer 1

layer 2

background layer

original photos

If an image is selected and then cut and pasted into another image, it will automatically form a new layer.

LAYER CONTROLS

Another great strength of layers is the ability to easily control how one layer reacts with another. The way the pixels react with those below it can be changed in remarkable and sometimes highly creative ways.

The most used device is Opacity; using this, the transparency of the active layer can be varied infinitely, allowing the layer or layers beneath to show through. The original data on the layer remains unchanged and can therefore be restored to full opacity at any time without damage.

The Fill command appears to be similar in the way it works, but actually it only affects the pixels painted on a layer; it does not alter any of the layer effects that may have been applied.

Blend is a complex wonderland found in many different guises within Photoshop; in this case it is the box at the top left of the Layers palette. The different versions all represent different ways of mixing the pixel(s) on one layer with the pixel(s) immediately beneath it. When blending layers together, or any other time you use a blend mode, such as when painting with a brush onto a layer, the resulting colour is a calculation based upon the colour(s) of the original image and the new colour(s) being applied to it.

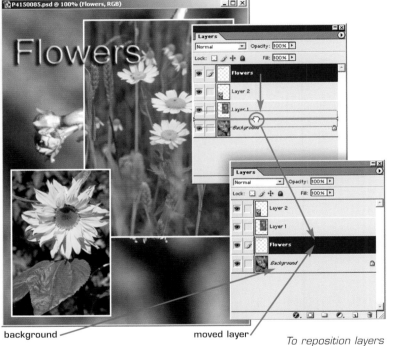

background

moved layer

To reposition layers within the stack, click and drag them into the required position.

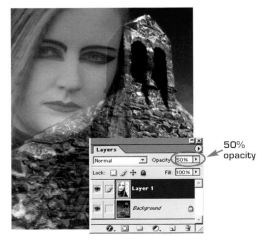

50% opacity

Many effects are possible if the opacity of a layer is changed. Here, the layer with the girl has been rendered 50% transparent.

THE BLENDING MODES (see also image on page 88)

	Normal	No changes are made.
	Dissolve	Random replacement of colours.
TO DARKEN THE IMAGE	**Darken**	Selects darker pixel from either layer.
	Multiply	Multiplies layers together; always darker.
	Color Burn	Increases the contrast.
	Linear Burn	Decreases the brightness.
TO LIGHTEN THE IMAGE (the inverse of the four above)	**Lighten**	Selects lighter pixel from either layer.
	Screen	Divides layers values; always lighter.
	Color Dodge	Decreases the contrast.
	Linear Dodge	Increases the brightness.
TO PRODUCE MORE COMPLEX MIXED EFFECTS	**Overlay**	Lightens or darkens the result according to the lightness or darkness of the base layer.
	Soft Light	Where the top layer is lighter than mid-grey, the result is lightened as if it had been dodged, and vice versa.
	Hard Light	Where the top layer is lighter than mid-grey, the result is lightened as if it had been screened, and vice versa.
	Vivid Light	Where the top layer is lighter than mid-grey, the result is lightened by decreasing the contrast, and vice versa.
	Linear Light	Where the top layer is lighter than mid-grey, the result is lightened by increasing the brightness, and vice versa.
	Pin Light	Where the top layer is lighter than mid-grey, pixels darker than this are replaced, and vice versa.
TO PRODUCE STRANGE EFFECTS	**Difference**	Subtracts one colour from the other, depending on which has the higher brightness value.
	Exclusion	Similar to the Difference mode, but with lower contrast.
USING HUE (H), SATURATION (S) AND LIGHTNESS (L)	**Hue**	Uses L and S from the base layer and H from the top one.
	Saturation	Uses L and H from the base layer and S from the upper layer.
	Color	Uses L from the base and H and S from above.
	Luminosity	Uses H and S from the base and L from above; the inverse of the Color mode.

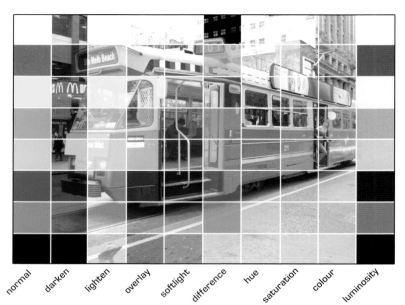

upper layer – original lower layer – original

normal darken lighten overlay softlight difference hue saturation colour luminosity

Blending compares one layer with another and then calculates the resulting colour to be placed. These are complex calculations, and the result is not always easy to predict.

MANAGING LAYERS

The layer that you are working on at any given time will be highlighted in blue and will also normally have a paintbrush icon in the second box from the left on the same line. The eye icon in the first column denotes that the layer is switched on and is active – think of it as a light switch, allowing you to turn off a layer to temporarily deactivate it without actually throwing it away.

Layers can easily get out of hand, especially if there are too many to be manageable. If this happens, consider lessening the number and thereby releasing the memory being used by them. To discard a layer no longer required, click and drag it to the waste bin at the base of the palette.

To merge and move layers, first access the small arrow at the top corner of the palette to show the options. Merge Down will merge the active layer, which is coloured blue, with the one immediately below it in the stack; Merge Visible will take all the layers that have an eye in the left-hand column and merge those, even if they are not directly above or below each other; and Flatten Image will do just what it says, compress all the layers into one single layer.

Clicking and dragging an unwanted layer to the waste bin deletes it from the stack.

layer switched off

actual image

Although a layer may be in place within the image, it is not necessarily visible. The top layer here can be seen in the palette but is switched off, so does not appear in the on-screen view.

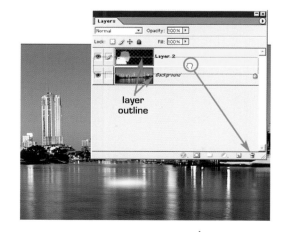

layer outline

The folder icon at the palette base allows you to group layers together, they are known as a Layer set and can be moved or worked on collectively. This shortens the stack considerably and can be a valuable organizational device.

Any individual layer or layer set can be locked to avoid inadvertent changes to it. The lock can be for 'Transparency', so that none of the clear areas can be changed; for 'Position' so that it cannot be moved on the layer; for 'Image' so that none of the pixel colours can be changed; or 'All' to disable the possibility of any work on the layer. If a layer is locked in any way – and the background is automatically locked by default – a small lock appears to the right of the layer name.

There are other more advanced items within the Layers palette, but the ones mentioned are sufficient for most purposes.

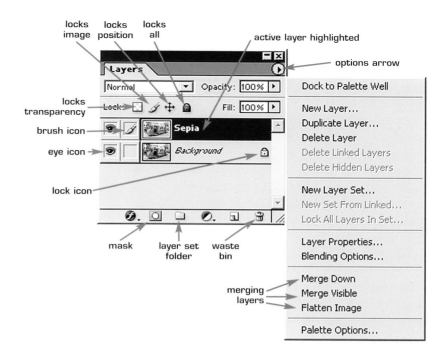

The Layers palette is complex, with many confusing icons. The main items are named here and are explained within the main text.

LAYER MASKS

This represents one of Adobe's masterstrokes – an understanding of layer masks is essential for efficient working within Photoshop.

The Mask icon at the base of the palette only becomes active if it is on a layer that is able to take a mask; the background layer is not able to do so, nor are more specialized ones, such as text layers. In the image of the young boy at left, a second layer has been made and the original background layer has been selected and then desaturated to black and white.

If you were to erase the top layer, the lower black-and-white image would show through the cleared areas, but the problem is that it would be hard to control and far too easy to make a mistake, since the original coloured layer has been altered irretrievably. The solution is to use a layer mask.

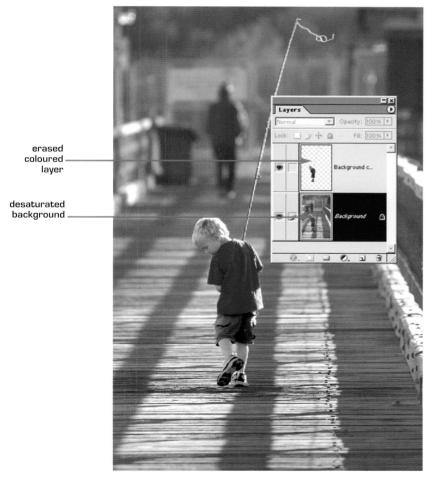

When a layer is erased, it allows the one beneath to show through. Unfortunately, the upper erased level is destroyed in the process, so it is not possible to easily restore the changes made.

After clicking the Layer Mask icon – a circle within a square at the base of the Layers palette – a white square forms alongside the layer thumbnail image, with a link between the two to indicate that they are connected. You may notice that when you activate the mask the brush in the second box is replaced by a mask icon, and also that whatever colours may have already been in the toolbox are replaced by the default black and white. So long as black is the foreground colour, if you begin to paint on this white surface with any of the painting tools, the mask will turn black.

This may seem unremarkable at first, but if you now view the image, the black areas painted onto the mask have become transparent in the same way as if they had been removed with an eraser. Of course, you will only see the changes if the lower layer is different to the one on top. If the paint colour is now changed to white, and we repaint over the parts previously painted with black, visibility of those areas returns to normal and any damage is undone. Painting with a shade of grey partly exposes the layer underneath – the darker the grey, the more of the lower layers it is possible to see.

The original image remains unchanged, and therefore undamaged, throughout the entire process. This is a massively powerful device that can be used to isolate and change areas without making complex selections, by simply painting away those areas that you wish to change. To assist, you have the entire army of Photoshop's extensive brush devices. If you try to throw the mask into the waste bin, you will be given the opportunity to apply or discard the mask to the image on that layer.

roughly painted mask

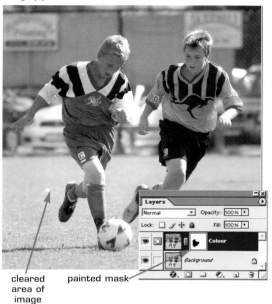

cleared area of image

painted mask

Using a layer mask it is possible to control opacity in different parts of a layer without permanently damaging the image. All actions are totally recoverable.

finished painted mask

Even after complete removal of the colour around the players, the original, fully coloured image is still in place within the Layers palette and can be recovered at any time.

ADJUSTMENT LAYERS

Nearly all of the powerful adjustment devices from the Image > Adjust menu can be used much more efficiently using Adjustment layers. This is a clever device activated by clicking on the icon at the base of the Layers palette.

Choosing from the drop-down list opens the appropriate dialogue box exactly the same as if it had been opened from the options bar, but with one major difference, any adjustments made here can be easily changed at any later stage, even after closing down and reopening the file. When a change of settings is made it is retained in memory, and when you reactivate it later the sliders and settings are exactly as you left them.

Adjustment layers have their own masks attached automatically. These work in the same way as layer masks: click on the mask if you want to change the mask, or on the adjustment icon alongside if you want to readjust the settings for the layer. Any adjustment layer affects all other visible layers in the stack below it, and can be repositioned in the same way as a 'normal' layer.

LAYER STYLE

The final icon at the foot of the palette reveals a drop-down list of styles that may be applied to layers. Click on any of the options, which all happen to lead to the same place!

The Layer Style dialogue box appears complex and has a myriad of effects that can be applied to layers, or to selections on a layer. Space does not allow them all to be pursued individually here, but try them out, initially on some text, and just enjoy. You will quickly get the gist of how they work, and if you like what you see then click OK, or even save it as a new style for future use via the New Style button. Click Cancel if you cannot find the effect that you are seeking.

Adjustment layers allow changes to be made to colour and tone without the risk of permanent damage to the image. They are saved with the image and can be reactivated at any time for further adjustment.

layer style box

The Layer Style box allows many special effects to be applied to any object on a layer. It's particularly useful for adding drop-shadows to a layer effortlessly.

Channels

ALL PHOTOSHOP IMAGES USE CHANNELS. IN THE CASE OF A BLACK-AND-WHITE IMAGE THERE IS ONLY ONE, BUT USUALLY THERE ARE A VARIETY OF DIFFERENT CHANNELS – THREE FOR ON-SCREEN RGB IMAGES AND FOUR FOR PRINTING IN CMYK.

In Chapter 1 it was explained that computers are colour-blind – they do not 'see' colour at all. To form a coloured image on-screen it is necessary to produce three or more different black-and-white images and then use the monitor to apply a colour to each of them, before combining them to produce the finished on-screen image.

RGB IMAGES

Images viewed on a monitor are displayed using red, green and blue only, and all other colours are formed from these three colours. In Photoshop these are allocated to separate channels, which can be viewed by opening the Channels palette from within the Window menu.

The clown colour card at right and below, together with the Channels palette, shows how the image would normally appear to the viewer. If you deactivate the other two channels you get to see the component parts as Photoshop sees them – as black-and-white images.

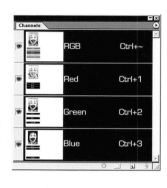

channels palette

Each of the three colour channels controls how much of that particular colour is included at any point within the image. The lighter the area, the more colour that gets through.

The separate channels each display a different black-and-white image. These act as masks excluding specific colours; the green channel, for example, only permits the passage of green, cyan and yellow.

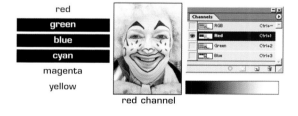

red channel

 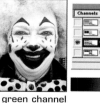 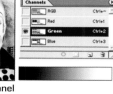

green channel

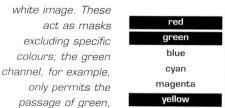

blue channel

Now when you look at the images, try to imagine that the darker parts of the channel, the black and grey areas, are masking the colour from that channel and the lighter areas are letting it through.

With the clown's collar and lips as an example, it is clear that the red channel in these places is very light, allowing a lot of red colouration through at that point. Now look at the corresponding areas for the blue channel and they are very dark: virtually no blue is allowed in these areas and the resulting collar colour has to be red.

This can be a little confusing, so to assist further coloured bars have been added alongside the individual channels; these are pure colour without any tone, so they must appear as either black or white within the channels. Here, it is clear that the red channel will only allow red, magenta or yellow through; green, blue and cyan are totally excluded.

PALETTES 18 CHANNELS

92

Likewise in the green channel red, blue and magenta are not permitted, and for the blue channel, red green and yellow are excluded in the same way.

An understanding of colour and the colour wheel is a useful attribute for anyone involved in digital imaging, particularly in relation to printing and colour matching. Red is on the opposite side of the wheel to its complementary colour cyan, and it is clear from the accompanying Channels diagram at right that the red channel permits its own colour and the colours immediately either side of it, but as you move around the wheel in either direction the channel becomes progressively darker, permitting less of the other colours in, until ultimately it permits none of the complementary colour at all.

If you prefer, it is possible to show the Channels palette in colour by going to the Edit menu on the options bar and selecting Preferences. Choose Display and Cursors, and then tick the box marked Color Channels in Color. When using Channels the palette will be artificially coloured to mimic the colour layer, but this adds little to the functionality of Photoshop.

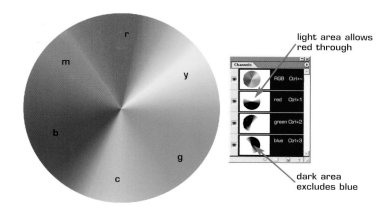

On the colour wheel the complementary colours are on opposite sides. It is clear that each colour excludes its complementary colour and any similar colours alongside it on the wheel.

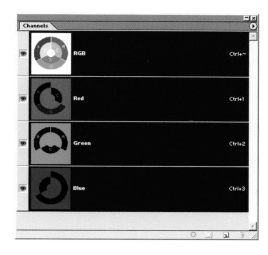

Channels can be displayed in their appropriate colour if preferred. This has no affect on the way that they work.

CMYK composite

cyan magenta

yellow black

Standard four-colour printing uses cyan, magenta, yellow and black channels. The use of black avoids dark areas becoming 'muddy'.

CHANGING CHANNELS

Channels are not always the same, because colour can be identified in a number of different ways within Photoshop. The other channel mix that will frequently be seen, particularly by anyone connected with printing or publishing, is the four-channel system CMYK. Cyan, magenta and yellow are the complementary colours to RGB and they are used in the printing process because when mixed together they become black, ideal for printing on paper. In reality, they do not actually produce a pure black when printed, because of impurities within the inks, so black is added to make the fourth channel and colour.

Any photograph within Photoshop can be viewed as CMYK on-screen by going to the Image menu and clicking on Mode. The tick will normally be alongside RGB, but if CMYK is clicked the image on-screen will change. Be aware, however, that this is an artificial change created by Photoshop – the photo is still being displayed on-screen using RGB coloured light, but the program has simulated what it may look like if it is printed commercially.

Don't be disappointed that the CMYK colour becomes duller; this is bound to happen since the bright colours generated by the intense light through the screen are simply too saturated to be reproduced on paper, as the pigments and dyes used are not bright enough.

RGB

CMYK

If colours are very bright in the original, they may well become degraded when converted to CMYK. This is largely unavoidable since the printing process cannot produce the highly saturated colours required.

degraded colour

LAB MODE

The remaining colour mode of interest to photographers is Lab mode, which treats the photo in a totally different way, based upon a complex three-dimensional diagram. The vertical axis defines the Lightness (L) and two opposing horizontal axis define the colours of the other channels (a and b). In itself this is unremarkable, but from a photographer's point of view it can be very valuable – effectively the image has now been split into its black-and-white component (L) and its colour component (a and b together), and this fact can be used in many different ways within Photoshop.

• Many workers choose to sharpen images here, since if the L channel is selected and then sharpened using Unsharp Mask from the Filter menu, only the black and white is altered and the unwanted colour artefacts are left untouched. After sharpening, remember to reconvert back to RGB.

- Conversion from colour to black and white is another option. If the coloured image is converted to Lab mode and the a and b channels are then discarded by being thrown into the waste bin at the base of the palette, you are left with just the pure monochrome information. This often gives a superior, clearer black-and-white result. If you do this, remember to change back to Greyscale mode afterwards, or parts of Photoshop will not function normally.

- After scanning, it is often the coloured channels that contain the stray pixels that make a scan unsightly; it's possible to adjust them here, using just the offending colour channels, or to even blur them slightly, so that they are less obvious when the L channel is reimposed on the a and b ones.

black-and-white channel

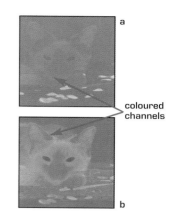

coloured channels

L

a

b

Lab is an interesting mode of working since it separates all the black-and-white information into one channel. The coloured content of the image forms the other two channels.

USING CHANNELS

Channels are frequently an ideal way to produce selections. Many coloured photographs do not clearly differentiate lines in the picture because of the colour, and it is always worth looking at the channels to see whether the lines are more obvious on one of them. If they are, a selection can be made using a single channel only, before reactivating the other channels and actually using the selection that has been made.

Images are not restricted to just the original three or four channels: via the icons at the base of the palette or the arrow in the top corner of the box, it is possible to duplicate, copy and delete channels in the same way as for layers. Most of these actions are pretty uninteresting outside of uses for the printing trade, and produce very strange results, but one is very important – the creation of Alpha channels.

An attempted Magic Wand selection of the tree was incomplete, because of the many different greens contained within it. On the blue channel all the tones were similar, and therefore the selection was a success.

parts missed from selection

magic wand selection from the original image

selection from blue channel only

ALPHA CHANNELS

This is a term that you will encounter many times, but one which causes much confusion. An Alpha channel is simply a mask channel; the masks that were covered back in Chapter 8 are specific types of Alpha channel.

If a selection is made within the image and then saved using Select > Save selection, an additional channel will appear within the palette. If it is not given a name it will be automatically called Alpha 1 – a much better idea is to type a name into the box for ease of identification later. More Alpha channels can be added at will, and each one represents a specific selection within the image.

alpha channel

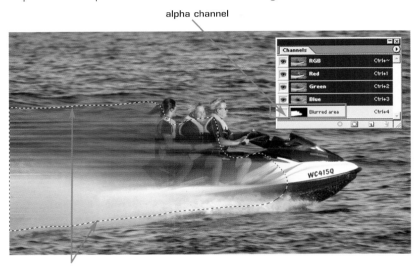

associated selection

If a selection is made within the image and then saved it becomes an Alpha channel, a new Mask channel added at the base of the palette.

Channels are combined using Select > Load selection. A selection must already be active within the image, and the channel you wish to act upon is selected within the palette. The operation may then be to add, subtract or intersect with the existing selection, giving lots of flexibility when building multiple masks.

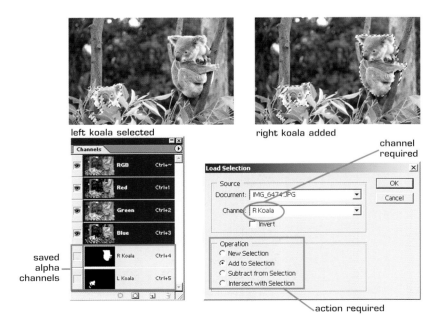

left koala selected

right koala added

channel required

saved alpha channels

action required

If more than one selection has been saved, it is possible to combine the Alpha channels for them using the Load Selection dialogue box.

Alpha channels can be painted upon, erased, duplicated and much more, so it is perfectly possible to make a selection, save it, modify it and if necessary make further selections to add to it, before combining all these actions into the final one required. Painting on a mask channel actually changes the shape and density of the resultant selection, and since you can work on it with any of the painting tools, it becomes possible to paint very sophisticated selections with varying density.

In the example of the surfer at right and below, it was important that before making any changes to the background tones and colours the 'white' surf was protected – if not, it might turn totally white and ruin the finished photograph. First a selection was made with the Lasso tool around and inside the wave edge, and then, using the Select menu, it was feathered heavily so that the edge became gradually softened. This soft selection was saved and became the first Alpha channel.

The problem now was that any changes made would inevitably affect the surfer as well – since he lies within the grey area of the Alpha channel and therefore is only partially protected – and would be gradually altered in the same way as the rest of the selection. This of course is quite unacceptable, so the simple expedient of painting with black as the foreground colour onto the Alpha channel only, completely protected the surfer from any action that

original image with new alpha channel named surf

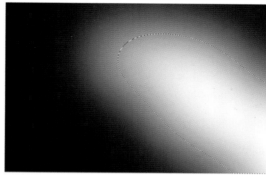

first alpha channel

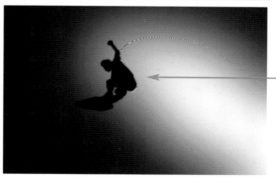

modified alpha channel

painted surfer

Alpha channels may be worked upon directly with any of the painting tools, making it possible to produce complex selections very simply.

In the finished image the white surf was retained using Alpha channels, allowing the conflicting background to be diluted.

might follow. The channel had now changed significantly, and when the selection was activated its new shape was clearly visible, due to the painted modifications. In reality these two selections, the surf and the surfer, were originally on two different layers, so using the Load Channel commands it was possible to include or exclude the surf channel and/or the surfer channel from any subsequent selections and alterations made. Dramatic changes have been made to show some of the possibilities.

The use of Alpha channels opens up enormous possibilities for complex selections, which would be almost impossible if attempted any other way. This is a powerhouse tool, akin to layer masking, and should be studied closely because the opportunities it provides are amazing. To finish the image I sharpened the area within the surf to make it more dynamic, lightened the surfer and increased the colour in that region, and diluted the background sea considerably to further emphasize the importance of the surfer.

History

THE HISTORY PALETTE IS A SHEER DELIGHT TO WORK WITH – THIS IS THE NEAREST THING IN PHOTOSHOP TO A TIME MACHINE, A BACK-TO-THE-FUTURE DEVICE THAT ALLOWS YOU TO RETURN AND USE EARLIER STAGES IN THE DEVELOPMENT OF AN IMAGE.

THE HISTORY PALETTE

Whenever you open an image the History palette records the event by forming an identical mini image at the top of the palette, which is known as a Snapshot. No matter what you do to the image, other than closing it down, this will remain in place and be available for use later.

Suppose, for instance that you took the surfer image at right and turned it into a line drawing using one of the filters, and then adjusted it further; it appears as if the original image has been totally changed, but by clicking back directly onto the original snapshot you can return to the start position.

Stages in the history of the image are known as 'states', and every action taken is recorded as a new state as the image is developed. The states created are only ever seen on-screen, and this means that they are operating within the computer's random access memory (RAM), so management of them becomes crucial.

The solution is to limit the number of history states to match your computer's capability. Under Edit > Preferences > General it is possible to change the 20 default states number. If your computer has less than 256Mb of RAM it would pay to decrease the default states to perhaps ten, but if you have more than 1Gb they could be increased beyond 20.

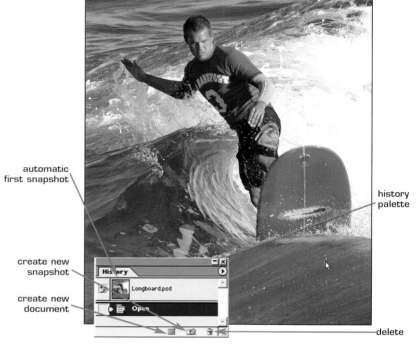

automatic first snapshot

history palette

create new snapshot

create new document

delete

The initial snapshot is formed automatically unless it has been switched off within the palette options. Leave it on for safety!

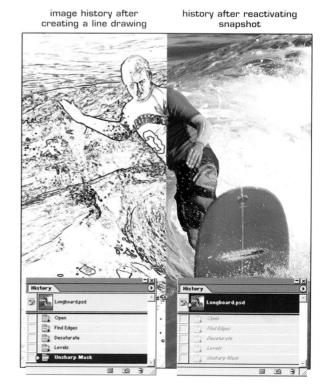

image history after creating a line drawing

history after reactivating snapshot

Clicking back onto the snapshot, even after significant work has been done on the image, restores it to its original unaltered state.

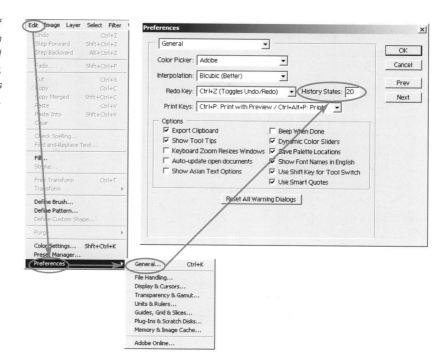

The number of history states can be accessed and changed if necessary, using preferences from the Edit menu.

ABOUT MEMORY

Scratch sizes may be selected from the pop-up menu at the base of the Photoshop window.

memory setting within preferences

used ram

available ram

click here for options

Memory is a constant problem within Photoshop, and the program is renowned as being immensely memory-hungry. New users often get confused between memory and hard disk size, since they both use the same units of measurement, usually seen as kilobytes, megabytes or gigabytes. Memory is the smaller number of the two, rarely more than 1Gb, whereas hard disks are frequently of many gigabytes capacity.

Within your computer the RAM handles the storage of data at very high speeds, almost instantly. When this is all used up, as it frequently is with the large file sizes used in digital imaging, the computer must resort instead to moving the data on and off the very much slower hard disk. This is very unsatisfactory because it slows the computer right down, and may, in the worst cases, result in on-screen messages telling you that there is insufficient memory to complete the task, or something similar.

Keep an eye on the memory usage via the box at the base of the Photoshop window; when it is set to 'Scratch sizes' it is showing the amount of memory being used at that moment. If the figure on the left – memory being used – is about to exceed that on the right – memory available – consider saving the image and reopening it, to release the memory being used, or getting rid of the history or any other clutter, including unused photos hanging around on the screen or on the clipboard.

Fortunately memory is only in use whilst the computer is on, and it restarts from scratch every time you reopen the program. Ultimately, if lack of memory available is a frequent problem, the solution may be to get more RAM installed – this is the one upgrade that will make Photoshop work more efficiently on almost any machine!

If left at the default setting Photoshop will continue to add new states until there are 20 in the list. As soon as the 21st action is completed the first one on the list will be removed, and from that point the list will continually change, leaving just the last 20 actions at any given time.

Once a series of states has been created it is possible to return to any previous point in the development of the image, provided that it is still in view, by clicking on that state within the palette. When this is done the states below the active one turn grey. If a different action is performed on the image, all the greyed states will be discarded and replaced with the single action just completed, so beware!

after 17 stages

after more than 20 stages

After 17 stages had been completed the image was returned to an earlier state. Once the list exceeded 20 states in total, they began to be removed completely from the top of the list and replaced by new ones at its base.

In the image of the old gentleman from Crete, all the states after 'Enter Quick Mask' have been greyed and would be discarded if any other work were now done. In fact, I returned to the last entry at the base and continued working until the 20 default states were exceeded; it can be seen that 'Enter Quick Mask' is now at the top of the list. If I now wished to get back to the earlier discarded stages it would be impossible, although the option to return to the original snapshot is always present.

To overcome the problem of only using a limited number of states Adobe found a killer punch – the option to save additional snapshots as the image progresses. At any time as you are working it is possible to click on the camera icon at the base of the palette, or access 'New Snapshot' via the arrow in the top corner of the box. When you do so the image at that point in time will be saved in memory, though not on the hard disk, and will remain available for use in the future.

The possibilities here are endless: if you have a lot of retouching or painting to do, which will use the 20 history states up very quickly, simply make a new snapshot before you start and that image will then remain available, provided again that it remains on-screen; History cannot be saved.

'CREATE NEW DOCUMENT' FROM CURRENT STATE

This icon allows a duplicate of the image to be made as it was at that time. This at first seems to be of dubious value, since it is much like the Image > Duplicate command, but in reality it can be a lifesaver. If, for instance, you have been working on an image and have to switch off the computer before it is completed, the whole history disappears and your work may be wasted. Using the 'Create new document' command you can go back and create each of the snapshots as different images before saving them as separate files.

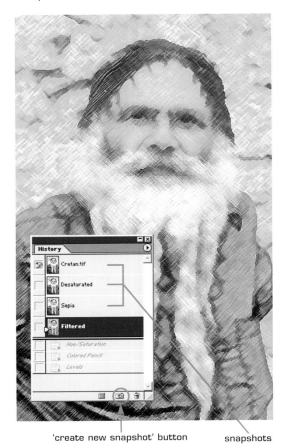

'create new snapshot' button snapshots

As the image was developed new snapshots were created. The History palette remains uncluttered, but the various images are still available for use.

If the images need to be reassembled next time, they can be simply cut and pasted into the new image. And because all of them are identical in size, they will always appear in perfect registration.

Snapshots can be named by double-clicking the name in the palette, or by way of the arrow in the top corner of the box; they can also be discarded by being dragged to the waste bin at the foot of the palette, as can any states already created if you decide that they are no longer needed.

There are a number of other minor options available from within the History palette. Simply select them as required.

access button

single layer

three snapshots

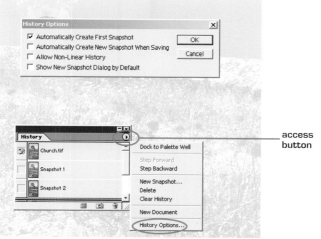

numerous states

After much manipulation the image has a long history and three snapshots in place.

initial automatic snapshot

snapshot 1

snapshot 2

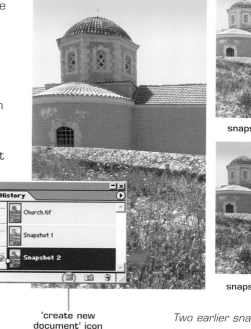

'create new document' icon

Two earlier snapshots have been converted into new documents using the icon at the base of the palette.

HISTORY BRUSH

If Adobe had stopped at the History palette no one would have been disappointed, but they went much further, and also gave us the History Brush. This should theoretically have been included with the section on tools, but it is so closely allied to the History palette that it is here, as the brush has no function unless used with this palette.

The brush can be found halfway down the toolbox, sharing a button with the Art History Brush, and if you try it on an image you may be surprised that nothing happens. I have known people to leave it at this stage and not return for some time; this is a big mistake. The 'trick' is that it must have a snapshot or history state in place before it can work.

The easiest way to explain how the brush works is to show it in action. This image is also on my website if you want to try it for yourself (see page 60).

The start image has been worked on in a number of ways: at three different stages a snapshot was created and automatically added to the top of the History palette. The individual images look like this:

horse

snapshot 1

snapshot 2

The three individual snapshots, prior to carrying out work with the History Brush.

history brush icon snapshot selected history brush selected

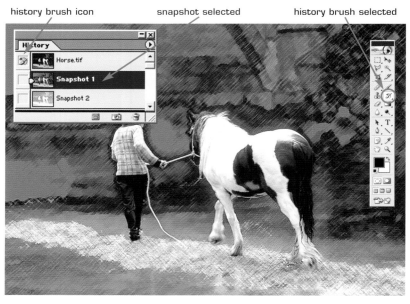

Painting on top of the horse and rider with the History Brush returns that part of the image to its original state, totally removing the effects applied later.

Here's the fun bit! I activated snapshot 1 by clicking upon it, but placed the icon that relates to the History Brush alongside the original horse image by clicking in the small box alongside. Painting over the horse and rider now returns the image back to its original state, but only in those areas where the brush is applied. It looks as though I am erasing through layers, but of course there are no layers, as this is all being done within History – clever stuff!

There are three important lessons here:

- The image will be captured from wherever the History Brush icon is positioned, in the column to the left of the various snapshots and states.

- The History Brush must be selected, no other will do.

- The image collected in the first stage will be painted onto the snapshot or state that is active – blue – within the History palette.

That's it, the full story; remember it and the History Brush is easy.

The second stage was to leave the active state as the last thing done, but then to move the History Brush icon to a new position alongside snapshot 2. Now any painting on the image would place the soft blue of that snapshot over the top of the developing image on-screen. Note that the History Brush was used diluted here, to facilitate the gentle transition from one state to the other. This can be done by setting a reduced opacity for the brush, but is much easier if worked in conjunction with a graphics tablet and stylus.

To complete the picture I used a flattened brush to erase the edges. The other great advantage of working like this is that if you get the image wrong at any time or wish to change your mind, you can return to the snapshot at that point and repaint the original back again.

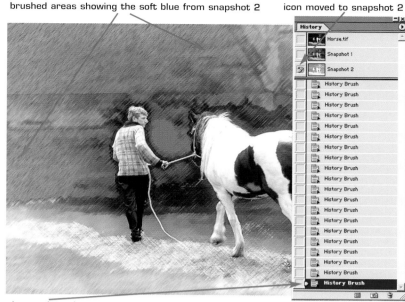

brushed areas showing the soft blue from snapshot 2

icon moved to snapshot 2

last action taken is selected

Painting over the outer areas with the History Brush icon alongside snapshot 2 replaces the image on-screen with the light blue snapshot.

Apart from the border, this is entirely the work of the History Brush and palette. This is a powerful tool if the computer is able to fully support it.

The Art History Brush was used here in Lighten mode at a reduced opacity, so that the effect produced could be adequately controlled.

ART HISTORY BRUSH

There's one other trick up the sleeve here. Beneath the History Brush in the toolbox is the Art History Brush, which works in a similar way but will also work from a single layer, applying pseudo-art effects as it does.

Using the controls on the options bar it is possible to produce a number of different effects and then apply them to the image on-screen. This is a 'play' tool and does not require instruction, but my advice would be to tone the effects down well with the Opacity controls, and think about using Blending modes.

Actions

ACTIONS ARE A REMARKABLE PRODUCTION TOOL WITHIN PHOTOSHOP, AS THEY ALLOW FREQUENTLY REPEATED OPERATION SEQUENCES TO BE OPERATED AUTOMATICALLY. FOR THIS REASON, ONCE YOU HAVE SET THEM UP, THEY ARE A GREAT TIME SAVER.

ACTIONS PALETTE

There are a number of actions available straight from the box. Accessed by way of the Window menu, the palette contains a default set of a dozen or more actions, and a click on the arrow in the top corner reveals more sets. A single click on any of these names will add that set to those available in the box.

Each set contains a number of actions; this is not a fixed number, and others can be added as and when you choose. A click on the small blue arrow to the left of the file rotates that arrow and opens the file to reveal its contents and more arrows. Click any of these and the actions are broken down further, and so it continues.

The best way to gain an instant understanding of Actions is to open an image and then, after selecting an action to use by clicking on it, press the right-facing arrow at the base of the palette – the 'Play' button. When you do so, the action as detailed in the palette will be applied to the image on-screen, step by step in sequence, until it is complete.

In just a few moments the computer has created a new layer and applied a series of actions to the image without any input at this stage from you. That's what it is all about – you do the work once, and then the computer repeats it using one simple command. In computer jargon this is known as a macro, but Adobe have cleverly removed the entire confusing programming bit and left a very simple device as a result.

default folder

default folder opened

additional folders

opened folder

The Actions palette initially appears to contain very little, but as the arrows are turned to unlock more detail, it lengthens. When the additional sets are loaded it contains hundreds of individual entries.

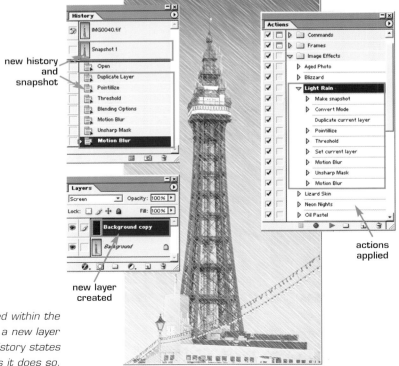

new history and snapshot

new layer created

actions applied

The 'Light rain' action, included within the package, produces instant rainfall, a new layer and a whole list of new History states as it does so.

PALETTES **20** ACTIONS

woodframe

molten lead

gradient map

sepia toning

These are four of the default set actions supplied with the program. Applying these to an image can sometimes produce surprising results, as in the molten lead example here, which was derived from the same original photo as the others.

CREATING ACTIONS

The supplied actions are rarely exactly what is required, and it is likely that you will wish to create your own at some point.

To create a new action, click on the New Action icon at the base of the palette – the sheet of paper – and a dialogue box appears, which allows you to give the action a name and also to decide which set it is to be placed into. All the sets that are already within the palette will be detailed here, but it makes more sense to first create a new set of your own. New sets are made from the folder icon at the base of the palette; a single click allows it to be named.

Having created your new set, it is now time to start creating the actions to go within it. Click the icon, name the action, and then, if you wish, allocate a colour to that action. If it is something you do very frequently, consider giving it a function key shortcut, so that it can be accessed directly from the keyboard.

The main controls within the Actions palette are along its base, or by way of the arrow and drop-down menu.

menu access

action set

modal controls

actions

include/exclude commands

stop record play new action set new action delete action

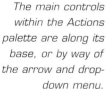

MAKING IT WORK

To avoid confusion I have reloaded the default actions and am going to walk you through the process of starting a set of actions. The first action is a type of border, so you need a new set to contain it.

Click on the Create New Set icon (1), name it Borders by typing inside the box (2). This forms a new folder set (3), and after clicking on Create New Action ensure that this is also the set selected in the new dialogue box (4). I named it Keyline, and because I intended to use it frequently, I assigned it to function key F2 for ease of access from the keyboard.

The process is a command to a computer, and as such must have no ambiguity whatsoever. All the following steps are needed to produce a perfect white keyline that can be reproduced effortlessly, at any time, on other images:

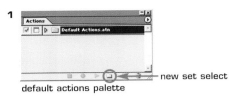

default actions palette — new set select

Follow the sequence shown to create a new set to hold the actions, and the title of the first action within it.

insert name here

new set title

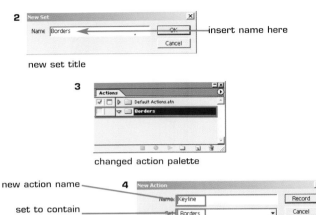

changed action palette

new action name — set to contain new action — keyboard access to action — action colour — new action dialogue

1 Click on the record button.

2 The layer is duplicated

3 Apply Select All. It would be useless drawing a selection by hand, because when faced with an image of a different size or shape, the computer would not know what to do.

4 'Shrink' the selection using Edit > Transform > Scale. Again, use percentage reductions so that they are applicable to all images.

5 Reset colour swatches to default black and white, and then invert them. There is no way to know what colours may be in these boxes at a later time, so resetting ensures that the computer understands.

6 Apply the stroke using Edit > Stroke, and finally delete the selection.

7 Click the Stop Recording button.

Now test the new action thoroughly.

If it is necessary to add an action that cannot be automated this can be accomplished by adding a stop. If you want the action to allow adjustments that are only available in dialogue boxes, modal control pauses may be added. These are shown in the palette by a dialogue box icon to the left of the action names.

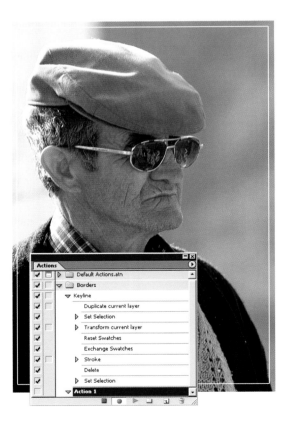

This action produced the white keyline effect around the edge of the image. Once completed, it can be applied to any photo in the future.

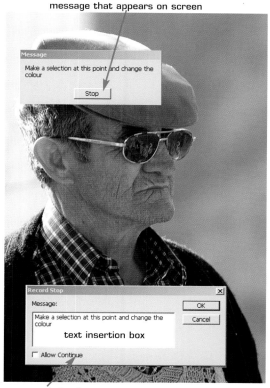

message that appears on screen

text insertion box

record stop box

Adding 'Stop' messages to the action allows a pause for work to be completed, and brings text on screen to remind the user what is required.

modal controls

The built in modal control has paused the action and caused the Hue/Saturation dialogue box to be opened so that adjustments may be made.

Modal controls can only be attached to actions requiring a dialogue box entry; they are formed by clicking directly into the box where the icon will appear. When the action is run, it will pause at that point.

Actions are powerful devices, but they do not have to run on single items. In the File menu, under Automate, there is a device called 'Batch', which allows for multiple applications of any action. There is not enough space to go into great detail here, but in essence it works like this:

- Insert the name of the set and the action you want to perform.
- Under 'Source' tell the computer where the images are to be found on the computer.
- For the destination, inform the computer where the images are to be placed after the action is completed.
- Rename the images under File Naming if you wish.

The final move is to head out for the evening, because the computer will now run through all the files that have been identified and carry out the action on every one of them – wonderful!

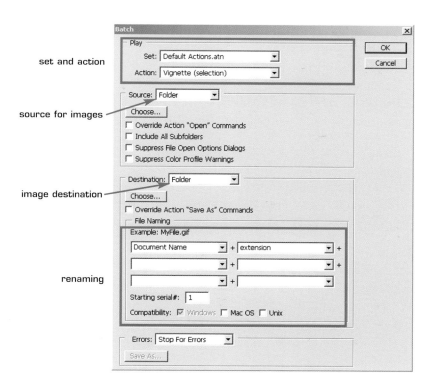

set and action

source for images

image destination

renaming

The Batch process dialogue box allows an action to be applied to numerous files unattended. This is a great production aid.

File browser

FILE BROWSER IS RELATIVELY NEW TO PHOTOSHOP, BUT IT IS A VERY WELCOME ADDITION. IN PHOTOSHOP CS IT HAS BEEN RAISED TO NEW HEIGHTS, AND FOR MOST USERS IT HAS REMOVED THE NEED FOR A THIRD-PARTY IMAGE ORGANIZER.

WHAT IS IT?

Clicking on File > Browse from the options bar – or in Photoshop CS, more conveniently, upon the small toggle folder icon with magnifier, that remains to the right of the toolbar at all times – opens the File Browser. The general File Browser arrangement is in four main sections:

- The Folders container requires little explanation, since it mimics the file structure of your computer and operates in the same way. There are scroll bars along the edges to use if all the folders are not visible, but more importantly, it can be reshaped and resized by moving over the border of the section and then clicking and dragging on the edge.

- Beneath folders is Preview. As an image is selected by clicking on it, it will also appear here. The sides can be moved to make the viewing area larger. When the preview first appears it has rough pixellated edges, but in a moment it redraws for final viewing.

- In the bottom left corner, sharing the same box, are Metadata information and Keywords. These contain information related to the image selected, whether captured at source from the camera or entered subsequently by the user.

- Finally the entire right-hand side is a superb viewing and sorting area, the nearest thing to a lightbox, used for sorting slides, that you are ever likely to encounter on a computer.

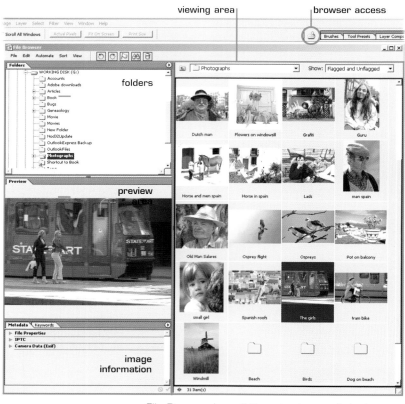

File Browser has all the advantages of viewing on a traditional lightbox, and many more besides.

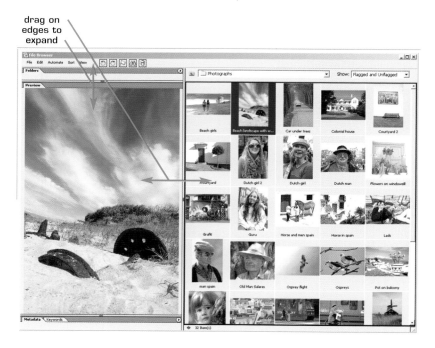

Drag on the borders of the Preview box to allow the viewing area to be enlarged. Double-click the thumbnail image or the preview to open it.

SLIDE SORTER

The slide sorter is a delight! It is now possible not only to view your images on the electronic lightbox, but it is also possible to choose how they are viewed and rearrange the order to suit yourself.

Clicking the image activates it and turns the surround blue; dragging while it is highlighted moves the image, and a heavy line appears at the new insertion point. In this way it is possible to sort the pictures easily and arrange them into an order of priority for viewing. Note that this is not possible in Photoshop 7.

Clicking directly upon the name beneath the image allows you to change the name; alternatively, via the Automate menu or by right-clicking on the image, you can rename a batch of selected files that allow the addition of sequential numbers, dates or various other options.

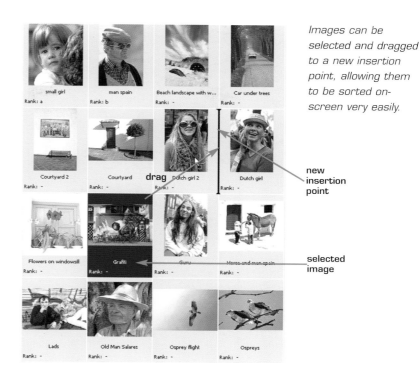

Images can be selected and dragged to a new insertion point, allowing them to be sorted on-screen very easily.

new insertion point

selected image

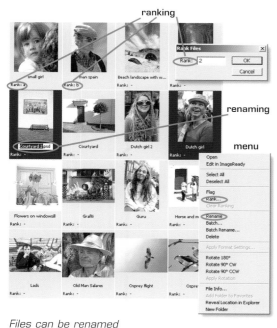

Files can be renamed and ranked in order without leaving the browser.

If images appear incorrectly orientated they can be rotated into the correct position using the rotating arrows at the top of the window. This is well worth doing because, apart from making them easier to view here, it also ensures that they open correctly within Photoshop.

If you need to highlight particular images it is easily done using the Flag icon: click on an image with this and it will have a flag placed into one corner, which will remain in place until removed. To remove it simply click on the Flag icon a second time.

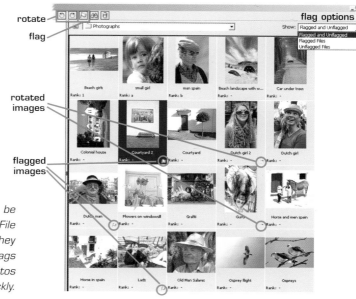

Images can be rotated within File Browser before they are opened. Flags allow specific photos to be identified quickly.

METADATA

When a photograph is taken with a digital camera it is no longer a question of just firing the shutter; along with that there is now an amazing and bewildering amount of data recorded as Exif information (**E**xchangeable **I**mage **F**ile). This information is part of the metadata that Photoshop extracts, and makes available.

Photoshop makes all of this available to us, but it is difficult to imagine who, apart from the camera manufacturers, might have a use for most of it. The basic data, however, can be a valuable aid when analyzing photos taken, particularly when trying to determine what went wrong on imperfect images.

There is also an accepted format for press use, defined according to the International Press Telecommunications Council (IPTC), which gives the opportunity to attach many further details about the image, such as who the photographer is, where it was taken, copyright ownership etc., all very important information if it is to be published.

There are further areas within Metadata, including all the computer information related to the File Properties of the image activated, but except for specialized purposes most users would not choose to activate this data from here; in fact most of it appears on-screen by just holding the cursor over an image for a short while.

When a photograph is taken on a digital camera, an amazing and comprehensive analysis of the related data is recorded. This is accessed when the image is opened and can be viewed in Metadata in Photoshop.

Mainly for the convenience of press usage, additional information can be added to the images within the IPTC area.

KEYWORDS

To the photographer, this is one of the most exciting parts of File Browser – for too long we have been playing with third-party programs or plug-ins to allow us to catalogue our images effectively, but at last we can do it all within Photoshop.

How often do you lose photos on the computer and wish you had some magic retrieval device to get them back? How much time do you take trying to find them? If you are like most of us the answer is 'Too much', so a small amount of time invested here will save all of that waste in the future.

Under keywords it is possible to accurately label your images for identification purposes, down to the finest detail, if that is what you need. The default options are limited, but it is very easy to turn this into a valuable tool.

File information can be obtained from File Properties, or by simply pausing with the cursor over the thumbnail image.

Think of keyword sets as folders that contain images that can be grouped together in some way, and keywords as subdivisions of those groups, and you cannot go wrong. New sets and keywords can be easily formed, either by using the drop-down menu in the corner of the box, or by clicking the icons at the base of the palette.

It pays to take some time thinking about the possibilities and requirements before you enter lots of information for the photos; although the sets and keywords can later be deleted, it does not delete the information entered for the individual images.

drop down menu

keyword set

search button

keyword

new keyword and set icons

full list

active image

ticked items

It is easy to catalogue your images after the addition of new keyword sets and keywords; finding them afterwards then becomes easy.

The example at left shows a fully catalogued image. New sets have been created to specify human characteristics such as age, and the check boxes alongside the name have been ticked where appropriate. Although this is time-consuming to set up, once it has been established it is a simple matter to click the appropriate boxes for each new image.

Keywords do not remove the need for sensible filing of your photos in the first place, but using them within the search facility makes finding pictures easy, no matter where they end up on the computer.

The default keywords list is severely limited, but it is well worth taking the time to modify it for your own purposes.

where to search

add new criteria

search options

The comprehensive search facility allows placed keywords to be used as part of a search.

MENU ITEMS

Moving items

THE CLIPBOARD

A readily available tool, which is common to virtually all software programs, is known as the clipboard. This is a device that is never seen within Photoshop, but it allows you to take all or part of an image and either cut or copy it away from the desktop.

When cut, it will be physically removed from the image border, and a space the size and shape of that removed will be filled with the background colour; when cut from a layer within an image, the lower layer will be seen through the 'hole' created. When copied it will still remain in the original photo, but a duplicate version will be stored on the invisible clipboard.

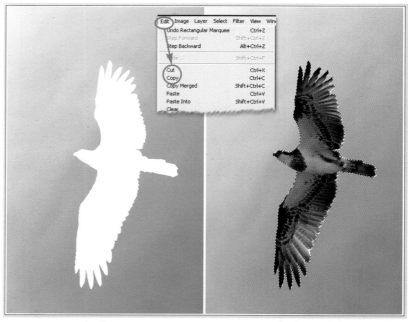

selection cut selection copied

Cutting a selection from its background removes the original, whereas copying removes a duplicate only; the original image remains undamaged.

Items held on the clipboard can be pasted as many times as required, until the information is cleared or replaced.

Once an item of any shape or size has been removed to the clipboard, it is held there in memory and will remain available for use until the computer is closed down, or until another item is copied or cut, when this new object will replace it. Working in Photoshop, it is only possible to have a single object on the clipboard.

The data on the clipboard does not clear itself when pasted; it remains in place, allowing multiple copies of an image to be reproduced if needed. Be aware, however, that the clipboard operates in RAM and therefore is constantly using your valuable memory. It is a good idea to clear the clipboard once you are sure that the information is not needed again, by clicking on Edit > Purge, and choosing clipboard.

When an item has been cut or copied, the Paste command becomes available in the Edit menu, allowing the item to be returned to the original image, or to any other image. It's even possible to paste images between different software applications, provided that the program understands the Photoshop file format.

Be warned that if you have selected an area and then copied and pasted it back into the same image, it can be disconcerting, because nothing appears to happen other than the selection border disappearing. This is partly due to the accuracy of Photoshop, since it places it onto a new layer, precisely over the original selection. The moral is to leave the Layers palette open!

pasted into microsoft word

Any image on the clipboard can be pasted back into the original program or into another image or application. Here, the altered photo was pasted into Microsoft Word.

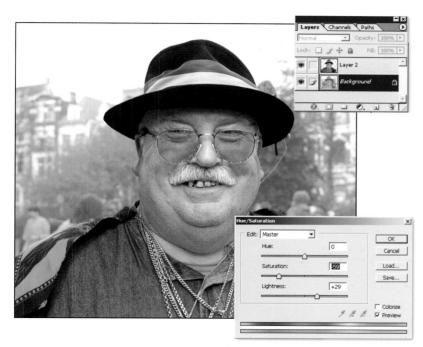

Cut and Paste allows pinpoint accuracy within an image, making it possible to copy a selection to another layer and work on it independently. Here, the confusing background was 'diluted' after cutting and pasting the man.

Incidentally, if you remove the selection before pasting this 'rule' does not apply; any object pasted from the clipboard without a selection in place within the image will position itself in the centre of the receiving image frame.

The implications of the accuracy of cutting and pasting into the same shape are enormous, because we now have a means of duplicating parts of the original and then working on the individual layers to complete the work or effect, without risk of damage to the original.

PASTE INTO

Another powerful device is the Paste Into command, which is available under the Edit menu on the options bar. This requires a selection to be in place within the receiving image. If an object is pasted into a selection within any image, Photoshop not only creates a new layer, but also a new layer mask. All the area outside the selection is masked, which means that the object pasted into it, although this remains complete in itself even while it is out of view, can only be seen within the selected area and appears on screen as though it were being seen through a window.

This has many applications because it allows for repositioning of the image within the selection 'window', a great aid to composition and creativity. Imagine a situation with a good landscape but a poor sky; after selecting the sky it is possible to cut and paste a new sky into it and then to move it around to get the best position, or even resize and rotate it while in position.

DRAGGING IMAGES

Another valuable option when moving an image is the simple drag and drop technique. Either the whole picture, or any selected part of it can be dragged using the move tool, this was mentioned briefly under 'Selections' but we need to consider it further here. Once the piece required has been isolated and the Move tool selected, simply dragging the object outside of the image frame and onto another image completes the task. A new layer is automatically created and therefore it is easy to relocate, resize and reshape the selection above the new background.

These images show the process of moving a selection from one photograph into another. The cursor dragging the new item must be outside its own original frame and over another image before the plus-sign icon appears.

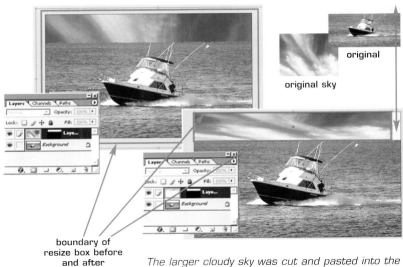

original

original sky

boundary of resize box before and after transformation

The larger cloudy sky was cut and pasted into the selected bare sky of the original, and appears within a mask. Here it is compressed to fit the shape using the Transform tools.

original landscape

selected balloon

dragged selection

completed with two layers

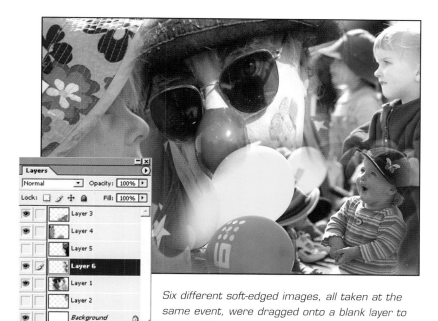

Six different soft-edged images, all taken at the same event, were dragged onto a blank layer to create this complex montage. The same sort of thing could be done for birthdays, weddings and many other situations.

MONTAGE

An obvious use for the drag and drop technique is montage, the process of placing multiple images upon a single layer. If items are selected and then feathered they can be very easily moved onto a blank or pre-constructed background and then arranged.

The beauty of doing it in this way is that the individual images remain editable throughout because they are each on a different layer, and complex selections are not necessary, since the edges are feathered and therefore merge gently into any adjoining image component.

The concept of dragging selections extends also to dragging layers or channels. If a layer is activated within an image and then dragged onto another image, that layer will be added to the current stack. Dragging a channel can be difficult, since it arrives in the new image as an Alpha or Mask channel and therefore is of limited value, unless you require that selection in the new image also. Even selection outlines, the 'marching ants', can be dragged between images provided that the Marquee or Lasso tools are selected in the toolbox, and New Selection is activated on the options bar.

One really valuable use for 'dragged' items is in the composition and positioning on a page prior to printing. When all the images are dragged to a new pre-constructed blank sheet of the size to be printed (using Image > New on the toolbar), they can be resized in situ and repositioned using the rulers and guides. This is a simple task because each image arrives on its own layer.

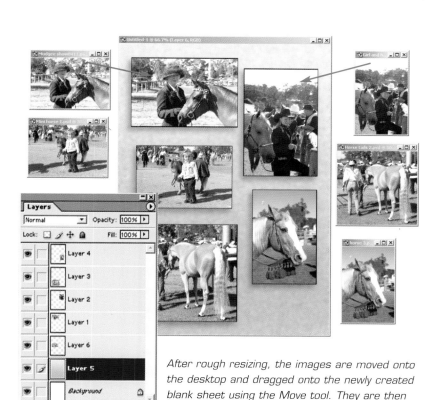

After rough resizing, the images are moved onto the desktop and dragged onto the newly created blank sheet using the Move tool. They are then reshaped and positioned using Layers.

Reshaping items

RARELY DO YOU FIND THAT MOVED ITEMS ARE OF THE RIGHT SHAPE OR SIZE WITHOUT SOME INPUT FROM YOU. WITHIN PHOTOSHOP THERE ARE SOME POWERFUL RESHAPING DEVICES TO HELP, KNOWN COLLECTIVELY AS THE TRANSFORM TOOLS.

TRANSFORM TOOLS

There must be a selection in place before any reshaping can take place, but once there is, Free Transform is undoubtedly the most versatile of the tools available. When activated, by selecting from the drop-down list under the Edit menu, a rectangular box with handles is formed automatically around the outside of the selected area. The box will always fully enclose the selection, no matter what its original shape may be.

The handles allow the sides and corners to be moved. Pulling on any handle distorts the selection in the direction that it is dragged. Corner handles reposition both edges that are connected to that handle. Pressing the Enter key accepts the redrawn shape and causes the image to change.

Pulling on the sides or corners of the Transform box causes the selection to change shape.

Care is needed when resizing an identifiable shape or the image will become distorted. To retain the shape it is necessary to press the Shift key while pulling a corner handle.

If the Shift key is depressed while pulling on a corner handle, the box will expand or contract as before but will maintain the aspect ratio of the sides, so that the selection does not become distorted. If the Alt key is held while pulling a handle, both sides of the selected area will change equally, instead of just the one side that is being dragged.

Moving outside the rectangular box changes the shape of the arrow into a curve; clicking and pulling while this is visible will cause the box to rotate around the small cross cursor in the centre of it, known as the reference point. Holding the shift key while turning will make the box rotate in fixed 15° steps.

The central reference point can also be repositioned; this is useful if you want to rotate the image around a different pivot point or around one of the other handles. Either click on a new reference point on the small diagram in the options bar, or click directly onto the central point and drag it to another location. Now if the image is rotated it will rotate around this new reference position.

Free Transform allows other options. To distort freely any handle around the box, hold down the Ctrl key while dragging; to apply perspective it is necessary to hold down Ctrl+Alt+Shift and drag a corner, but by this time I think it is getting a bit silly and it is better to refer to the individual Transform options. Shortcut keys are great while they can be easily remembered, but when they get to three levels, like this one, it just gets out of hand.

The individual Transform controls are found beneath Free Transform in the Edit menu:

Scale	allows the selection to be resized as before.
Rotate	works from outside the box in the same manner as the Free Transform tool.
Skew	works by pulling on any corner to move only that point in the direction of movement. Pulling on a central handle causes the rectangle to move only at that end.
Distort	allows the movement of any corner point freely. The other three corners remain fixed.
Perspective	behaves like the Skew command if pulled at a central handle, but when pulled at a corner, the opposite corner on the same line moves in sympathy to shorten or lengthen that line.

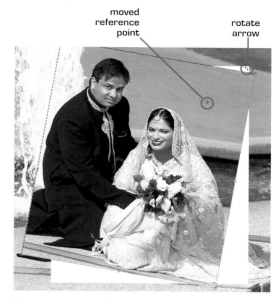

moved reference point rotate arrow

The cursor arrow becomes curved when it is outside the box, allowing the image to be rotated by pulling.

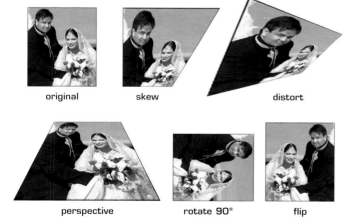

original skew distort

perspective rotate 90° flip

The choice of transform type determines the effect on the selection. Other options exist to rotate and flip the image.

Using Alt, Shift and Ctrl can modify many of these transformations; it is always worth experimenting with them as you practise.

The remaining controls facilitate rotation to fixed amounts or for flipping the selection in a vertical or horizontal plane. For this sort of precision, consider using the numerical entry devices in the options bar, which ensure much greater accuracy.

Transform tools are fine if you want to move in fixed directions, but are almost impossible if you need to squeeze or bend the selection. These types of movements are more difficult to control, but they are available.

LIQUIFY

The Liquify command is tucked away under Filters on the option bar. Clicking upon it opens a new interface, where all of the work is completed, before applying it to the actual image. The box is a little daunting at first glance, but it is not difficult to master.

There are three main components – on the top left are the tools; in the central area is the single image that was active on the desktop at the time of opening Liquify; and to the right are the numerous options available.

Rather than long explanations, the easiest way to deal with the tools is to list them. You will gain far more by looking at the diagrams showing the result and by trying them out for yourself.

forward warp

twirl clockwise

pucker

turbulence

bloat

mirror

thaw mask

freeze mask

push left

Using just the mesh one can see what each tool does; the only one that is not obvious is the Mirror tool. The red freeze mask has stopped the pixels from moving beneath that area.

Forward Warp tool pushes the pixels as you move the mouse.
Reconstruct tool returns pixels to the original unaltered state.
Twirl Clockwise tool rotates the pixels beneath the brush shape. It continues to turn them for as long as you remain in that spot. Pressing Alt at the same time reverses the direction.
Pucker tool pulls pixels towards the centre of the brush area.
Bloat tool pushes pixels away from the centre of the brush.

Push Left tool moves pixels to the left of the direction dragged. With Alt depressed they move to the right.
Mirror tool makes a mirror copy above or below the brush, depending on whether the Alt key is pressed.
Turbulence tool mixes pixels together smoothly.
Freeze Mask tool stops any pixels from moving by painting a mask over the protected area.
Thaw mask removes the 'frozen' areas.
Zoom tool/ Hand tool behave as they do in Photoshop's main toolbox.

tools mesh over preview image

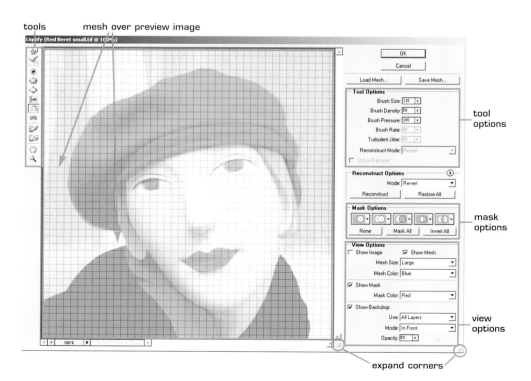

tool options

mask options

view options

expand corners

Liquify is in three main sections: the tools, preview area and options. Note the option to expand corners and increase the box size.

The tool options allow the brushes to be customized. Brush Size is obvious, and can in any case be controlled from the keyboard using the square-brackets keys; Brush Density concentrates the movement towards the cursor in the centre of the brush as the number is lowered, and Brush Pressure is how strongly it acts on the pixels beneath. The best way to use it is in conjunction with a stylus for more control.

Mask options are similar to those used within Photoshop, although the icons have been glamorized. In place of New there is Replace Selection, and there is also one totally new one, Invert Selection; Add To, Subtract From, and Intersect are the same.

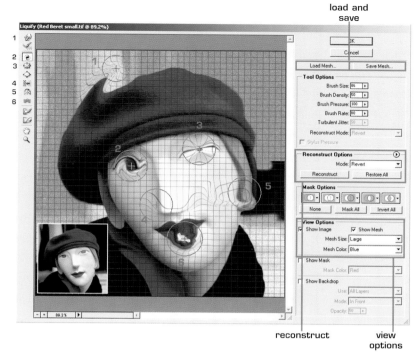

load and save

reconstruct view options

The two lower view options allow the mask to be seen, switched off or re-coloured. Show Backdrop allows the layers beneath to be partially visible in a number of controlled ways, even though you are actually working on a different layer.

Load and Save make it possible to close the Liquify box without finishing the task, or to place the same mesh onto another image.

Reconstruct gives a number of options for restoring a worked image to its original state. Restore All returns everything back to the start position. View Options is where the visibility of either the mesh or the image are controlled, again with a number of further options available.

The composite image at left shows an actual worked example, with the face totally reconstructed within the Liquify box. This is an extreme example, but used with care, making just small movements, it is possible to make significant changes within an image without them being obvious.

The actual effect of using the tools on an image can be seen here. You can choose whether to have the mesh or image visible. This image also has View Image clicked; compare this with the picture opposite below.

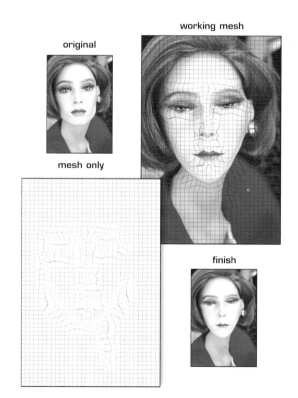

original

working mesh

mesh only

finish

The changes here were all brought about using only the Liquify controls.

Tonal control

LEVELS IS ONE OF THE MOST ESSENTIAL DEVICES WITHIN PHOTOSHOP. IT ALLOWS VERY FINE CONTROL OVER IMAGE TONES AND, TO GIVE SOME IDEA OF ITS IMPORTANCE, IT WOULD BE TRUE TO SAY THAT MANY PEOPLE USE THIS ON EVERY IMAGE THAT THEY CREATE.

BRIGHTNESS AND CONTRAST

Before launching the real powerhouse, let's look first at the easier concept of controlling brightness and contrast.

Under Image > Adjust in the options bar are some of the most powerful controls within Photoshop. Brightness/Contrast is perhaps the simplest of them. Clicking on it opens a dialogue box with just two sliders. The central arrows are the start position and moving them changes the brightness and/or contrast. It's as simple as that! Provided that the preview box is checked the changes may be seen immediately on-screen. This is so simple that it is tempting to use it all the time, but that's a big mistake, as other tools here give greater control and much more flexibility.

LEVELS

The use of Levels to control these same two factors raises the whole process to a higher level. Found right at the top of the powerful Image > Adjust drop-down menu, Levels opens a much larger and more complex dialogue box, but it is not that complex, so don't stop now – this one is important!

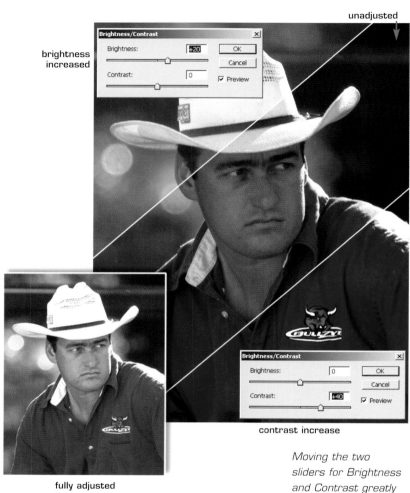

brightness increased

unadjusted

contrast increase

Moving the two sliders for Brightness and Contrast greatly improved the overall image.

fully adjusted

Both the Levels and the Brightness/ Contrast controls are found within the Image > Adjust menu structure. Here are to be found the most powerful devices within Photoshop, and after learning the toolbox, this should be the student's first priority.

It is first necessary to understand what you are looking at before you start to make adjustments. The bar graph or histogram automatically records the tonal values of every pixel within the image (or selected area) and then arranges them along a single base line with three control arrows upon it. The darkest pixels with the low numerical values are to the left, and the higher, lighter values to the right.

Think back to the early chapters and you will recall that the scale used runs from 0 for pure black pixels to 255 for white ones, and it is the same here. Those two values are shown in the Input Level boxes, together with a third midway value that represents a mid-grey tonal value of 128, even though it is recorded here as a value of 1.00.

access to individual channels

black (0)

mid-grey (128)

white (255)

The levels shown here display a fairly good distribution across the graph, with both black and bright pixels and a peak towards the mid-grey point. The result? A well-adjusted image.

very dark original

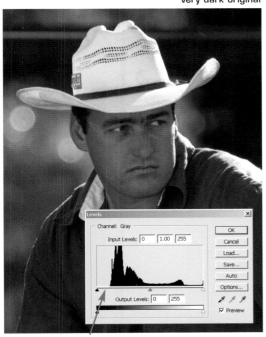

no pixels at the dark end of bar

Although this is a very dark image, the histogram in Levels clearly shows that there are actually no black or near-black pixels in it at all.

To make it even simpler, think of it like this: the computer has rushed around this image and inspected every one of the 492,000 pixels that it contains, and recorded the brightness values for each of them. It then takes all those with a value of 0 and stacks them one on top of each other like bricks at the extreme left-hand side of the box. It then moves on to those with a value of 1 and stacks them alongside the first pile, and then 2, 3 and 4, until it eventually reaches the pure white dots, with a value of 255 and stacks them on the extreme right-hand side, completing the histogram.

The importance of all this is that you now have effectively a 'map' of your image, presented in the way it is seen by the computer; with a little experience you can identify individual parts of your picture and problem areas within it, before setting out to correct them.

For comparison purposes I have used the same photo at left as on the facing page, but I reduced it to monochrome for simplicity. Although in its unadjusted state it is very dark, you can tell that there are no black dots with a value of 0 anywhere within it, because there are no columns of pixels at the left-hand side of the bar.

READING THE INFORMATION

Levels in the coloured version reveals a similar structure, but not the same. This is because it takes account of the black-and-white information found on all three channels and constructs the composite by adding them together.

The photo at right is largely made up of four areas of colour – the hat, face, background and shirt – and two of these, the face and shirt, are very similar. These areas can be identified on the accompanying levels diagram for each channel and are clearly visible on the composite.

For example there are large areas of the photo with values for blue between approximately 35 and 65, and the corresponding high levels values in this region on the histogram can be clearly seen. The high red peak at around 96 is seen in the values within the image for the background, the shirt and, although not marked here, the face.

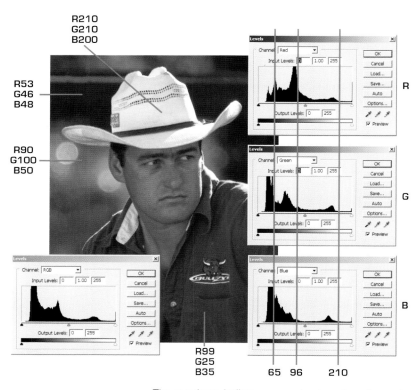

R210
G210
B200

R53
G46
B48

R90
G100
B50

R99
G25
B35

65 96 210

R

G

B

The numbers indicate approximate values for red, green and blue in these areas.

When tonal information is removed from the image, only pure colours are left and it is easy to see the similarity of areas within the photograph.

MAKING CORRECTIONS

When the image needs to be corrected, the solution is to move the sliders. Any of the points may be repositioned, and conventionally the end arrows are pulled just into the histogram before the centre point is adjusted to alter the 'exposure'. Pulling the centre arrow to the right will darken the overall image, and to the left will lighten it.

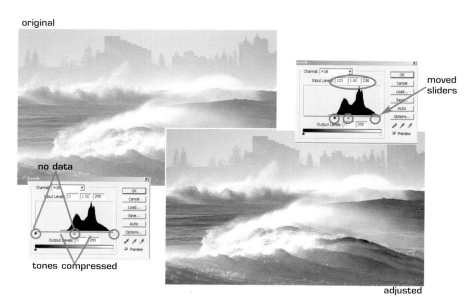

original

moved sliders

no data

tones compressed

Corrected image as a result of moving the arrows beneath the histogram.

adjusted

The 'washed out' seascape example here shows the result clearly. In the original all the tones are compressed. The output bar beneath the diagram, although not intended for this purpose, shows that the darkest tone is only slightly darker than mid-grey and that the lightest one is not quite white.

By moving the end points into the graph I ensured a full range of tones from black to white in the image, but as a result the overall effect was too dark. To correct this, I pulled the central control to the left. If you are wondering why should this be better than Brightness and Contrast, it is because of this centre point. By moving the outer arrows first I retained an absolute dark pixel and an absolute bright one and then spread the tones out evenly across that range using the centre arrow. There is no limit here; you can adjust the individual channels to control the colour; there is even an Automatic Levels control, but this rarely works well.

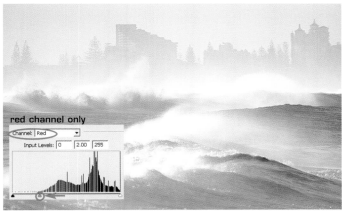

arrow moved to left

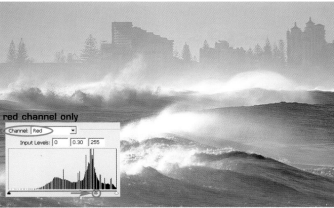

arrow moved to right

If you are brave enough you can experiment with the digital equivalent of Ansel Adams's zone system, using the Eyedroppers. Click on the tone that you want to be black with the dark one, the pixel you want to be white with the light one, and then the fun bit – click on mid-grey with the grey Eyedropper! Up to now it has worked fine, but if there is a colour cast at the point chosen for grey, no matter how slight, it will also change the colour of your image. It works really well on black-and-white pictures.

Finally, at the base of the palette, Output Levels allows you to control the tonal range as seen by your printer. If you find, for instance, that with a dark image your printer is placing too much black ink onto the paper in its attempts to mimic the very dark tones seen on-screen, it is possible to 'fool' it into seeing this as less dark by pulling the dark output arrow towards the centre. This has the effect of lessening the contrast, and can at times be very useful.

Using only the red channel in Levels it is possible to change the colour. Moving to the left increases the red value, while pulling to the right introduces more Cyan, the complementary colour.

Colour correction

PHOTOSHOP SEES COLOUR AS A SET OF NUMBERS AND IS THEREFORE ABLE TO IDENTIFY MINUTE VARIATIONS THAT THE HUMAN EYE COULD NEVER DIFFERENTIATE. SEVERAL OPTIONS EXIST WITHIN THE PROGRAM TO HELP YOU USE THIS ABILITY.

COLOR BALANCE

This is perhaps the simplest means of correcting a colour problem. Within the powerful Image > Adjust menu, clicking Color Balance releases a dialogue box with a few easily understood controls.

The Tone balance controls allow colour to be directed to light, mid or dark areas within the image, but in reality it is quite difficult to see the effect. Preserve Luminosity ensures that the image brightness does not change when more colour is applied. That's it: no further information is needed here, it is just a question of moving the arrows until you are satisfied with the result.

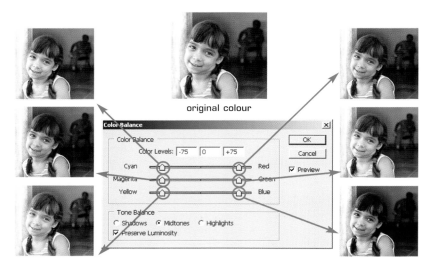

original colour

This is a composite image to show colour changes, as a result of adding or subtracting 75 on each of the sliders. When the box was first opened, there would normally be one control arrow at the centre of each line.

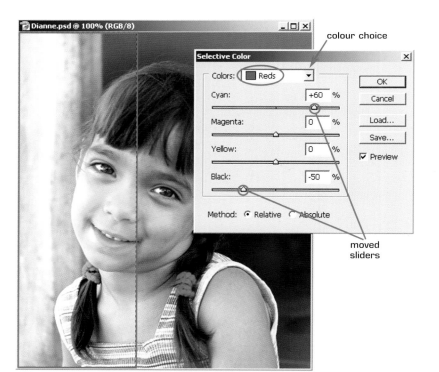

colour choice

moved sliders

By selecting Reds before moving the sliders in the box, it was possible to adjust this colour independently of the others. The reddish tinge on the girl's face was totally removed without the need for time-consuming selections.

SELECTIVE COLOR

Another more complex device for colour adjustment is Selective Color, found further down the Adjust menu.

This is really intended for professional pre-press users who work in CMYK, but it still works for RGB images. Here, you select the colours or tones you wish to change from the drop-down list, and alter them with the sliders. This is a powerful tool since it allows alterations to be made easily, even to complex colour casts in specific areas of your image.

CHANNEL MIXER

This is another valuable option because it acts directly upon the individual channels. Choose the channel that you think may be causing a colour problem from the drop-down list, and then use the sliders to change the percentage of that channel that is being used in the picture; only very small movements will be needed.

The best use of this control is for producing high-quality black-and-white images. If monochrome is selected it is possible to move the sliders and selectively add or remove density from each of the channels until you are satisfied.

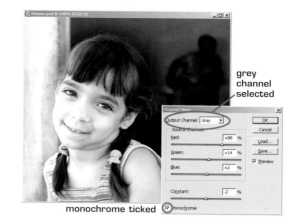

grey channel selected

monochrome ticked

Channel Mixer is one of the best ways to convert an image to black and white, since it allows individual control of the input from each channel.

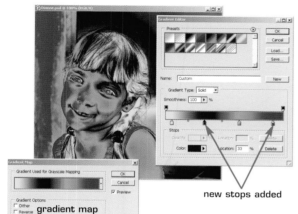

new stops added

gradient map

Wildly imaginative posterization is possible when colour is applied using Gradient Map.

In the start position it is set to give a full value (100%) for the red channel and no input from green and red – this is equivalent to using only the red channel. Input from the other channels by way of the sliders will not only change the black-and-white content of the image, but will also adjust the density. To avoid this, make sure that the three values are around 100% when added together, or adjust the Constant value slider.

OTHER POSSIBILITIES

Gradient Map places a colour ramp across the image. Clicking directly on the ramp opens the Gradient Editor and here, by clicking on the edge of the ramp, new stops can be placed to create gradient colours of your own choice. These are then automatically attached to the appropriate tones within the picture and can produce some startling posterizations.

Replace Color allows the user to select a colour within the image by simply clicking upon it with the mouse. The degree of acceptance of colours around the one chosen is governed by the Fuzziness control, and the colour to replace it is selected by clicking the Result swatch and making your choice.

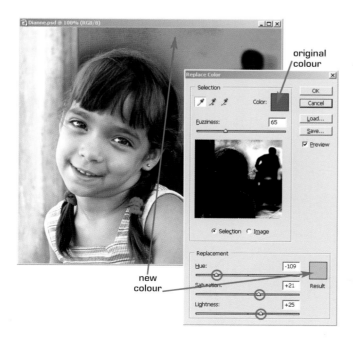

original colour

new colour

In Replace Color, the light areas within the preview window show the selected colours, chosen by clicking on that colour in the image. They are changed to the new colour by repositioning the sliders or by using the colour swatch.

CURVES

The best, but unfortunately the most complex, device for adjusting colours is undoubtedly Curves, an immensely powerful tool in the image adjustment armoury.

Curves and Levels have a lot in common, but whereas Levels is restricted to just three adjustment controls, in Curves there is no limit; each of the 256 values can be altered independently.

The two gradient bars alongside the grid give a good idea of the basic concept. Where the black ends come together, in the bottom left-hand corner are all the darkest pixels in the image, and at the top right, where the projected light ends of the bars would meet, are the lightest pixels. The diagonal line in fact represents every pixel in the image, and at any position along it values are assigned according to the pixel's brightness at that point – O (black) to the left, 128 (mid-grey) in the centre and 255 (white) to the right. The 'active' spot on the diagonal line is marked with a black dot and its values are recorded in the Input and Output boxes beneath the grid. In the first case here the spot has a value of 128, for both the input and the output. In other words, no changes have yet been made.

Adjustments can be made for the composite channels, or for any individual one. Channel selection is made using the arrow in the Channel box above the grid.

The diagonal line represents the unchanged input and output values for all the pixels in the image. Points on the line can be moved to change pixel values in the finished image.

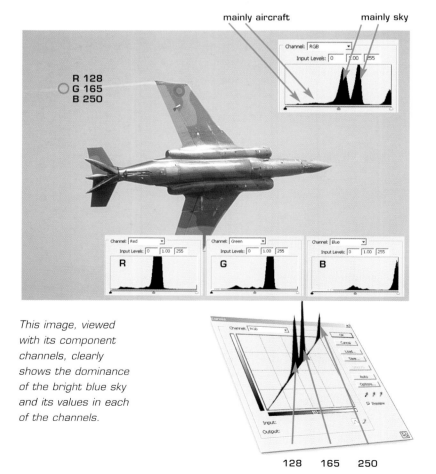

This image, viewed with its component channels, clearly shows the dominance of the bright blue sky and its values in each of the channels.

To help in the understanding of Curves, I have shown in the aircraft image at left a set of colour values for a single sampled spot in the sky, together with the channel information and composite taken from Levels. It is clear that the values around 128 red, 165 green and 250 blue are responsible largely for the sky colour.

When this same set of levels values for the same aircraft image is placed along the Curves diagonal you are now able to see clearly the actual values for those points, and hopefully see the relationship between Levels and Curves.

When the Levels values for the aircraft image are placed along the diagonal in Curves, it can be seen that the entire image information is contained on this one line.

Whereas in Levels the baseline was fixed, here it can be moved and bent, changing the values as it does so. Making the line steeper increases the contrast, while making it shallower decreases it.

The values in the image at right show that where the contrast was decreased the black value was increased in brightness, making any black dots a dark grey shade; the light dots were toned down to a light grey. Now instead of having a full range of tones from black (0) to white (255), it only contains a range from light grey (63) to dark grey (191), which reduces the contrast. The opposite is true for the increased contrast area.

Another point comes from this, that if you move any point on the curve up the grid then pixels of that tone within the image will become lighter, but if you drag them down the grid they become darker. To prove the point I made two changes to the aircraft shot, as seen below. First, I lessened the contrast and darkened the area in the upper quarter of the curve, where I knew the blue of the sky to be, thereby reducing the vivid blue to something more acceptable; and second, I increased the brightness at the darker end of the image slightly so that the deep shadows under the aircraft were lessened. A simple change in the curve makes a dramatic difference.

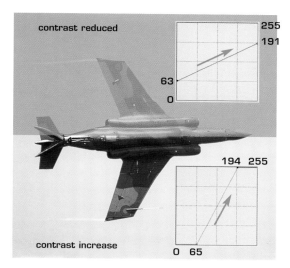

Altering the steepness of the curve changes the values of the points along it, giving the image more or less contrast.

Repositioning a number of points, by clicking on the line and then dragging them to a new place, has allowed the shape of the curve to be changed. The image is significantly different with only minor changes.

There are many other possibilities here, the most significant being the use of a single channel, where the curve then becomes a highly sophisticated colour adjustment tool. Entire books have been written about the Curves dialogue, such is its complexity.

To end on a fun note, if the curve is severely distorted, crossing and recrossing the original diagonal, wild posterizations will occur, since the colours within the image are being changed dramatically. This, however, is not accidental; because of the high degree of control given within Curves it is possible to design them exactly as you wish. Enjoy!

The points have been changed so radically here that the result is posterization, with total reversal of some of the colours into negative form. Total control of the colours is still retained.

Further correction

point sampled

HSB values

Hue, Saturation and Brightness values are used here to define a point in Color Picker. The numerical values are different to those for RGB, but the resulting colour is the same.

HUE, SATURATION AND LIGHTNESS

In Chapter 6 I considered two ways of defining a colour, RGB and CMYK, but alongside these was another alternative: HSB. This stands for Hue, Saturation and Brightness and is a different way of using three numbers to define a colour.

Open a photo and click Image on the options bar, choose Adjustments and then click on Hue/Saturation. The Hue/Saturation dialogue box will appear on screen.

The sliders allow you to adjust the values for Hue, Saturation and Lightness (don't worry about the change of name – Brightness and Lightness are the same thing in Photoshop). By setting a value for each of them it is possible to define any colour we choose.

Think of the colours as if you were an artist about to mix them on a palette. The three sliders work together, and any colour can easily be made in this very simple way:

- First, you would select a pure colour; this is the **hue**.
- You might dilute the colour, which affects its **saturation**.
- Adding white or black paint adjusts its **lightness**.

The original image, before moving the sliders in Hue/Saturation. Colours are unchanged on the bars and Hue, Saturation and Lightness are all centralized.

colours the same

CHANGING HUE

Moving the Hue slider will change the colour of the entire image or any selected part of it. At first it may appear random, but it's not – it cycles through the entire spectrum, remapping the colours as it goes. The easiest way to understand it is to look at the two coloured bars beneath the image: the upper bar shows the original colours and never changes, but the bottom one moves relative to it to display the new colours. The original colours on the top bar are replaced by the colours immediately beneath them.

In the example at right, the Hue slider has been pulled to a position of +84. As a result the lower colour bar has shifted to the left and colours on the original that were red have now changed to green, for example the breast feathers. At the same time, because all the colours are remapped, the green on the bird's back has now changed to blue.

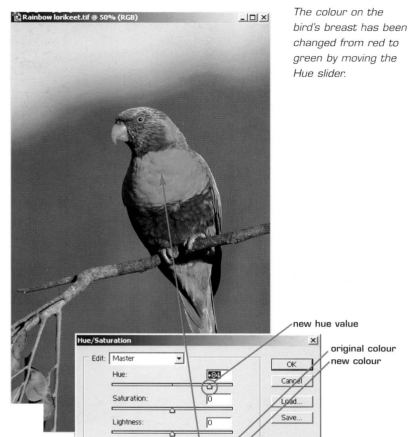

The colour on the bird's breast has been changed from red to green by moving the Hue slider.

new hue value

original colour
new colour

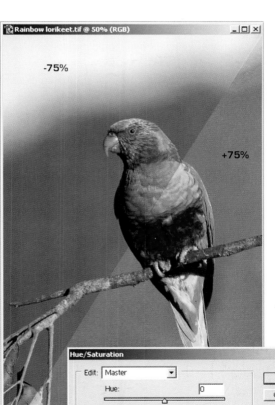

-75%

+75%

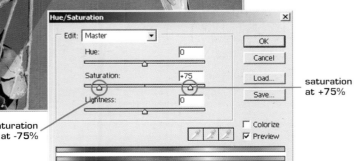

saturation
at -75%

Moving the Saturation slider alters the intensity of the colour but does not change the hue.

saturation
at +75%

If this is a little confusing, just look at the top bar to see the original unmoved green colour, and then look immediately below it to the lower bar to see the new blue colour of the feathers.

CHANGING SATURATION

Saturation reflects the depth of colour in the image, and as you move the Saturation slider to the left the intensity of colour reduces, although the original hue does not change. If the slider is pushed fully to the left, the image looks like a black-and-white one. Moving the slider to the right increases the saturation of the colours in the original. This can be a useful device for emphasizing part of your image – first select the area, and then subtly increase its colour using the Saturation control.

CHANGING LIGHTNESS

The Lightness slider changes neither the Hue nor the Saturation, so the original colours will remain identifiable. Moving the slider to the left darkens the image, and moving it to the right lightens the image.

This may appear to have limited value, but the graphics world uses it all the time to emphasize text. If you have a complex image where it is difficult to put text onto it and still ensure that it is easily read, one solution is to lighten part of the image to take the text, yet still allow the image to be seen through it.

WORKING IN CHANNELS

By default the small Edit window in the Hue/Saturation dialogue box shows 'Master', which simply means that any changes made will affect all the colours in the image. One of the great strengths of Photoshop is hidden away here, because it is also possible to isolate individual colours and work only on them.

Clicking the arrow alongside the Edit box reveals a list of six colour channels. Click on any one of these and that colour is isolated by placing stops between the upper and lower colour bars.

Now if the Hue slider is moved, the colours of the lower bar appear to emerge from within the stops; only the selected and isolated colour changes within the image, other unselected colours remain unaffected. In the example at right 'Reds' were chosen and then the Hue slider was moved; this resulted in any red within the image changing to green, since that is now the corresponding colour on the lower bar between the stops.

Selecting 'Reds' and moving the Hue slider makes any red within the image change to another colour, in this case green.

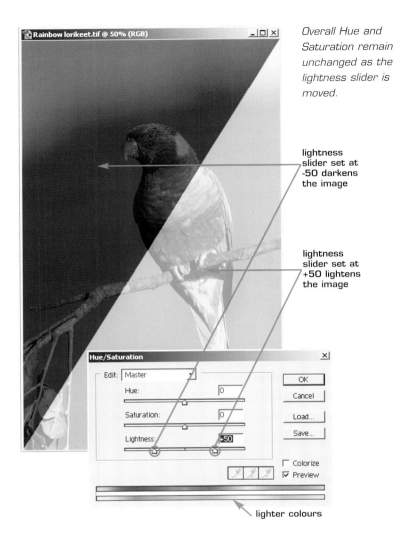

Overall Hue and Saturation remain unchanged as the lightness slider is moved.

lightness slider set at -50 darkens the image

lightness slider set at +50 lightens the image

lighter colours

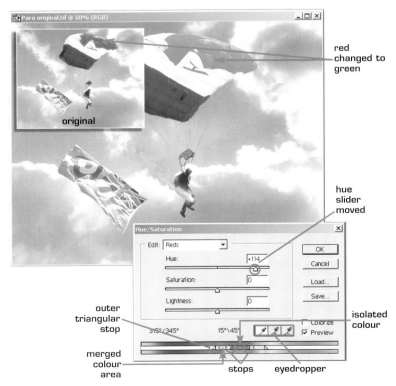

red changed to green

hue slider moved

isolated colour

outer triangular stop

merged colour area

stops eyedropper

To ensure that the colours merge seamlessly into each other there is a lighter grey overlap area, enclosed between the stops and the small triangles and between the two coloured bars. The original colour here, as shown on the top bar, represents the gentle merging of red into the other colours in the spectrum either side of it.

The stops and the triangles can be moved manually by clicking and dragging them along the line, but it is better to use the eyedroppers. It is unlikely that the colour required would be one of the six offered, but selecting the eyedropper and clicking in the image on the colour you wish to change always works.

If more than one colour is needed or there is a lot of variation in the colour chosen, working with the plus and minus eyedroppers can help. Click on the appropriate dropper and then click in the image on the other colours that you wish to change; this will adjust the stops for you automatically.

The new colour replaces the old colour anywhere that it is found within the picture, so in this case the red of the canopy changed as well as the red of the flag. If you wish to change only one item, normally only a rough selection around it, avoiding anything of the same colour, is all that is required. This is a wondrous device, and it is well worth spending the time to master it, since it can save hours of work.

loose selection made
around the red area
to be changed

The canopy was changed to blue using Hue/Saturation. The area was first roughly selected to avoid it affecting the red in the flag.

COLORIZE

There is one final surprise. Clicking the Colorize button changes the bottom bar to a single colour, and therefore the original image colours will be replaced by a single tint. This is excellent for producing sepia-toned or blue-toned effects, and with nearly 17,000,000 colours available, the one you want is sure to be in there somewhere!

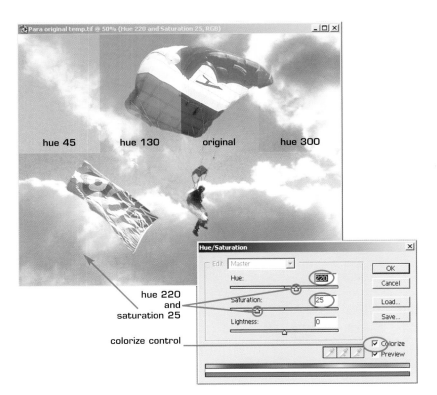

Tinting effects as a result of using the Colorize control within the Hue/Saturation box.

Other options

MAGIC ERASER

Both this tool and the Background Eraser try to make use of the erase facility in an 'intelligent' way; they are tucked away beneath the Standard Eraser in the toolbox. The Magic Eraser is similar to clicking with the Magic Wand continuously, but as well as selecting the area, it also deletes it. The settings available include:

- **Tolerance** determines how close to the colour of the pixel clicked upon the erased colours needs to be. The larger the number here, the more colours will be deleted.
- **Anti-aliased** allows the edge to remain soft and not pixellated; this would normally be left on.
- **Contiguous** removes only the pixels that are in contact with the one first clicked; if unchecked, they will be removed anywhere within the image.
- **Use All Layers** collects the colour from any of the layers, not just the active one.
- **Opacity** determines how much of the coloured original is removed.

The process is very simple: click on the colour you want to eradicate and all of the pixels of that colour, and those close to that colour, according to the settings chosen above, will be removed from the image.

When using Magic Eraser it makes great sense to duplicate the layer you are going to work on first, so that it is always possible to retrieve from it any of the areas that did not erase perfectly.

Using the default settings, just two mouse-clicks using Magic Eraser removed most of the blue background. Damage to the peak on the cap was caused because the colour was too similar to that of the sky.

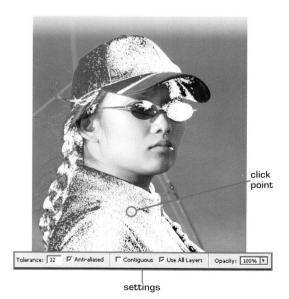

Clicking on the jacket with Contiguous switched off, not only removed the dark pixels of the jacket but also other dark areas within the photo, wherever they were.

BACKGROUND ERASER

The intention here is to keep the centre point of the brush over those colours within the image that you wish to remove; when the chosen colour has been selected, it will then be removed from all of the area contained within the brush circle. There are a number of options that alter the way that it works:

- **Contiguous** only erases the selected colours if they are in contact, whereas **Discontiguous** selects the colour anywhere within the brush area, useful when trying to select a complex wispy area, such as the edges of hair.
- **Find Edges** erases connected pixels of that colour only, but tries to preserve the sharpness of any edges detected.
- **Tolerance** determines how near the pixel colour must be to the colour of the central point before it is erased.
- **Protect Foreground Colour** tries to prevent the colour that is in the foreground swatch of the toolbox from being erased.
- **Sampling** offers three options. **Continuous** allows you to keep moving, and the image will be erased as you go; **Once** will take the colour first clicked and only remove that colour until you restart; **Background Swatch** only erases colours that are similar to the current background colour.

Effective use of the Background Eraser needs a little practice and skill. Sharp, clearly defined edges are easy and best tackled with a small brush, but ill-defined edges are often easier using a larger Discontiguous brush. Single clicks remove the least amount of colour, but if you click several times or stay in one place with the mouse button depressed the effect builds and expands beyond the brush edges – so be warned!

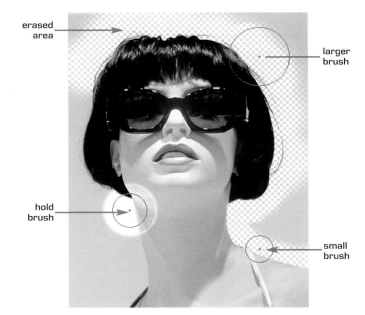

Using a larger Background Eraser brush around the loose hair allowed the background to be selected with the brush centre point well away from the edge.

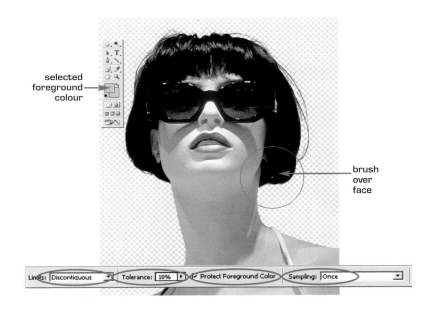

By selecting the face colour as the foreground colour, activating Protect Foreground, selecting a low Tolerance and switching on sampling, it was easy to remove the background.

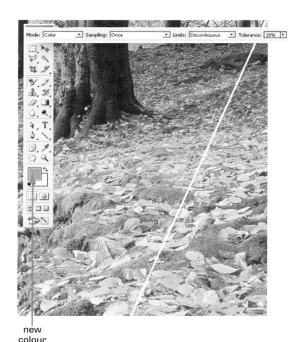

new
colour

The colours on the left have been enhanced by first selecting more saturated colours in the foreground colour swatch, and then, using the Color Replacement tool in colour mode, painting over the entire area.

COLOR REPLACEMENT

Here's another interesting one – Color Replacement allows specific colours within the image to be changed without any need for selections, which is a great time-saver.

There are four working modes: Hue, Saturation, Color and Luminosity. Working around these it is possible to 'select' a colour beneath the centre point of the brush and then use this in either a Continuous, Once or Background Swatch basis, just like the Background Eraser. Taking a little care in selecting the start position, it is possible to modify complex originals and alter the colours within them.

PHOTO FILTER

With the arrival of Photoshop CS came a number of new devices. Among these is the Photo Filter, which attempts to mimic the effect produced by conventional glass filters that are placed onto a camera lens when taking photographs.

This is very straightforward to use: simply click the filter button and select from the list, or alternatively 'construct' your own filter by selecting the appropriate box and then clicking on the coloured swatch alongside. Density allows control of the intensity of the filter, and Preserve Luminosity stops the exposure of the image from altering because of the changes made.

IMAGE > ADJUST EXTRAS

At the base of the Image > Adjust menu are some 'oddments' that have no real connection with each other. The easiest way to see what they do is to click on them with an image on-screen (see opposite), since they are all very simple.

- **Invert** produces a true negative of the image.
- **Equalize** attempts to ensure that there is a black and a white pixel represented in the image and then 'balances' the exposure. This is similar to the Auto Levels feature.
- **Threshold** divides the image into just black and white pixels; the slider determines where in the tonal range the division between these is placed.
- **Posterize** reduces all the tones in the image to a specified number of levels. In a black-and-white image, set to four levels, there would be just four tones, but in a coloured image four are produced for each channel.

A strong warming filter (85) applied across the image using Photo Filter produces a toned effect across the image.

invert

equalize

threshold

posterize

These four effects are to be found at the base of the Image Adjustments drop-down menu. They are all very easily applied.

colour | fine/course slider | tone

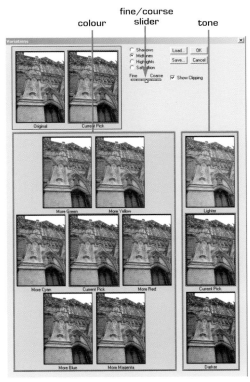

The Variations box allows very accurate visual adjustment of colours and tones within an image, without the need to understand the finer details of colour adjustment techniques.

VARIATIONS

Although this is another way of adjusting colour, it has been left until now because it is so different to any other device in Photoshop. Clicking on the name at the base of the Image > Adjustments menu opens another large viewing area.

The original image is in the top left of the images below, and will not change whilst the box is open. Alongside is Current Pick, which is the current state of development in the image and is repeated again in the centre of the colour variations, and also between the lighter and darker images. The images surrounding the Current Pick in the main box are all slightly different in colour to the central one, the degree of difference being changed by moving the Fine/Course slider.

Here's how it works. View the images, and if you see one that you prefer, perhaps because it is a better colour than the original, click directly onto it; this then replaces the current pick as the central image. If it is still not right, you can either select a different image and they will all change again, or you can move to a finer adjustment on the slider, and then consider your decision further. If it is too dark or too light, simply click on the upper or lower box to change that also.

This is an interactive box, where everything changes as you make the decisions. It is a process of refinement; you keep clicking the images and improving your photo until you are fully satisfied. When you are totally happy, click OK and all the adjustments you have made will be applied to the appropriate image on-screen.

Essential filters

THE FILTER MENU CONTAINS AN AMAZING ASSORTMENT OF SPECIAL EFFECTS. ALTHOUGH ENTIRE BOOKS HAVE BEEN WRITTEN ABOUT THEM, MOST OF THEM REQUIRE NO INSTRUCTION WHATSOEVER, YOU JUST GO IN AND 'PLAY'. IT'S WONDERLAND!

EXTRACT

This one really is in the wrong place – it isn't a filter like the rest, but unfortunately that's where it has been placed by Adobe. When accessed the image reopens in its own screen, which operates independently of the on-screen image.

The general idea is to identify the piece that you are interested in by surrounding it with a coloured line, and then to fill the centre with another colour, so that Photoshop will know which piece to save. Preview sets the Extract process into motion and Photoshop attempts to identify all the pixels that should remain, based upon your selection. It's not always perfect, but it is a good starting point, particularly for complex selections that contain fine detail.

At right a line was drawn carefully around the machine using the green highlighter. When it was completely enclosed (don't worry about the screen edges) it was filled with blue using the Paint bucket. Pressing Preview produced the result below.

A green highlight has been drawn around the machine, and it has been filled with blue to identify the area needed. Pressing Preview now will initiate the extraction process.

Although not a perfect selection, this can be cleaned up very effectively using the Cleanup and Edge Touchup tools from the Extract toolbox.

Although the extraction is not perfect, you can now proceed to tidy the selection using two very clever tools:

- **Cleanup** Painting normally will remove more of the previewed object; when Alt is held down at the same time, the image will reappear in the cleared areas. If the area requires transparency, like hair, the number keys allow the opacity of the stroke to be changed; higher numbers increase the effect.
- **Edge Touchup** This cleans up the edges and allows them to be pushed around until the right location is found. The opacity works the same as for Cleanup.

Press OK when the preview looks good, and the entire result is applied to the image on-screen.

There are further controls here, but with these simple ones it is quite easy to get a satisfactory selection from the most difficult of images. If you are in any doubt about what is happening, just keep an eye on the very useful interactive tool information bar.

FILTER GALLERY

A welcome new addition to Photoshop CS is the grouping and collective application of filters, made possible within Filter Gallery.

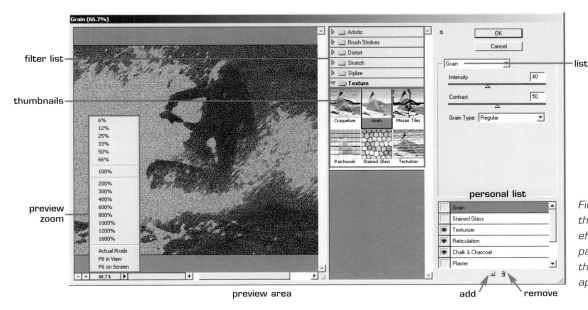

Filter Gallery simplifies the process of adding effects filters, particularly if more than one filter is to be applied to the image.

- On the left is a resizable preview area with scrollbars and a zoom facility, easily accessed from the arrow beneath the box, or more simply with the + and – icons.
- In the centre are stacked 'drawers' containing the filters, accessed via the small arrow alongside the file icon. When the file is opened, thumbnail previews of the filter effect are visible. If this facility is not required, click on the inverted chevrons to close it down.
- The variables for each individual filter appear in the top right of the box and change as each new one is opened.
- In the bottom right corner you can mix and match filters in a personal list by clicking on the icons underneath. This allows you to play around with ideas and then change your mind by individually switching the filters on or off using the eye icons.

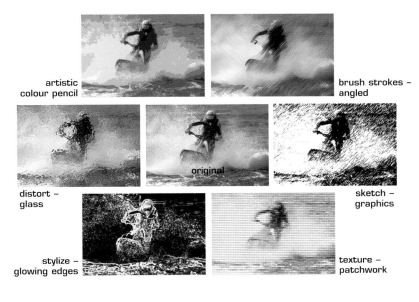

artistic colour pencil

brush strokes – angled

distort – glass

original

sketch – graphics

stylize – glowing edges

texture – patchwork

Representative filters taken from each of the filter 'drawers' within Filter Gallery.

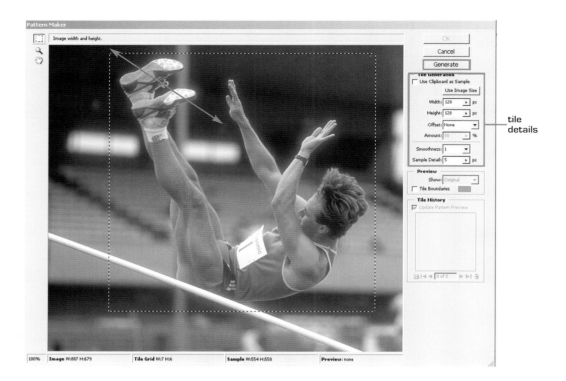

tile details

PATTERN MAKER

The Pattern Maker is also within the Filter menu, but is very different from the others contained here. It allows a portion of an image to be selected with the Rectangular Marquee tool and then converted into numerous patterns. Selection of the final pattern can be made from these. Clicking on the name opens the new interface.

The Pattern Maker dialogue is very simple, with few tools and straightforward settings to produce the tile required.

Once an area has been selected, pressing Generate produces a pattern based upon the selection, but this is only the start. After the first selection the name changes to Generate Again, and every time you click another different pattern will appear and will be saved.

The numbers beneath the Tile History record how many samples are available and they can be scrolled through and reviewed for possible use using the video-type controls. Factors such as Tile size, the offset of the tiles from each other, and whether they retain a border can all be set before accepting the finished tile.

pattern generated

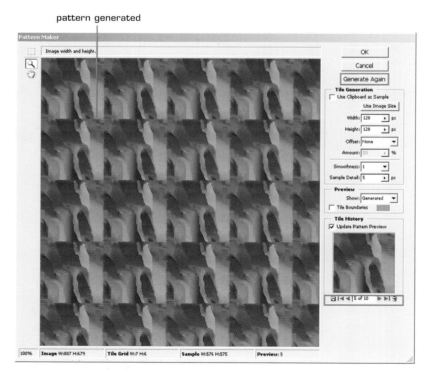

One of the patterns generated from the high-jumper image. Clicking 'Generate Again' several times produced other examples, and there are now multiple patterns to choose from.

BLUR AND SHARPEN

There are many other filters here, which were not included in the Filter Gallery, and the best way to learn about these is to sit and 'play' for a while. I have singled out a selection from just two of the groups because these contain some of the best and most important filters.

Within Blur you are given the opportunity to soften the pixels in your image, which Photoshop is able to do extremely well. As a general rule forget the basic Blur and Blur More, which give the user no control over the end result. To retain full control use Gaussian Blur, which has a simple lever to control the amount applied.

Lens Blur arrived with Photoshop CS, and gives a whole range of opportunities to try and simulate the effects produced by traditional lenses. They are good fun as long as they are not taken too seriously. Motion Blur can be used to simulate the effect of panning a camera to produce lines of movement in the image, and Radial Blur gives dynamic effects by positioning the centre point within the image.

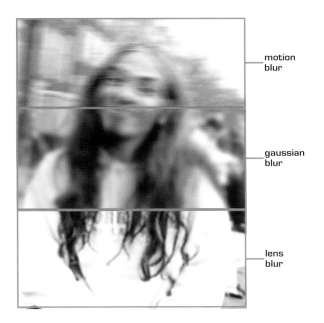

motion blur

gaussian blur

lens blur

Three of the many blur effects that are possible within Photoshop.

Radial Blur can be used in a number of different ways. Here, the face was protected with a mask and Radial Blur was applied to the background.

The Sharpen filters should be treated with some caution because they can seriously damage an image. The problem is that whereas Photoshop can easily mix the numerical values of adjacent pixels and then calculate new values to blur an image, the same approach does not work for sharpening. Sharpening is really an increase in contrast between groups of pixels, and this can produce very noticeable artifacts at the edges unless carried out with care.

The advice here is the same as for Blur – do not use the methods that allow no control, and that is every one except for the all-important Unsharp Mask. This is probably the most important of all the many filters, and although it sounds like a contradiction in terms, is by far the best way to sharpen the completed image. It is nearly always necessary to sharpen after manipulation, and most workers would not consider sending the image to print without a final 'tweak' here. Treat this as the final stage in the manipulation process.

Unsharp Mask settings depend upon the image size, but as a guide for starting, leave Radius on 1.0, Threshold on 0 and Amount somewhere between 50% and 150% and you cannot go far wrong.

Perhaps the finishing point for images is the right place to conclude the book. I hope you have enjoyed the journey – and good luck with the wonders of Adobe Photoshop!

WOLVERHAMPTON LIBRARIES

Keyboard shortcuts

BELOW IS A LIST OF SHORTCUTS THAT WILL HELP YOU TO NAVIGATE YOUR WAY AROUND PHOTOSHOP WITH GREATER SPEED – PLEASE NOTE THAT IT IS NOT A COMPLETE LIST OF ALL THE POSSIBILITES.

B	Brush tool
C	Crop tool
D	Default paint colours
E	Eraser
G	Gradient tool
H	Hand tool
J	Healing tool
L	Lasso tool
M	Marquee tool
P	Pen tool
Q	Quick mask mode
R	Blur tool
S	Rubber stamp tool
T	Type tool
V	Move tool
W	Magic wand tool
X	Exchange colours
Z	Zoom tool

IF USING THE LIST BELOW ON A MACINTOSH COMPUTER, SIMPLY SUBSTITUTE: COMMAND KEY INSTEAD OF CTRL; OPTION KEY INSTEAD OF ALT

Ctrl-A	Select all
Ctrl-B	Colour balance
Ctrl-C	Copy
Ctrl-D	Deselect
Ctrl-H	Hide edges
Ctrl-I	Invert image
Ctrl-L	Levels
Ctrl-M	Curves
Ctrl-O	Open file
Ctr-P	Print file
Ctrl-R	Rulers – show and hide
Ctrl-S	Save file
Ctrl+Shift-S	Save as
Ctrl-T	Free transform
Ctrl-U	Hue/Saturation
Ctrl-V	Paste
Ctrl+Shift-V	Paste into
Ctrl-X	Cut
Ctrl-Z	Undo last task
Ctrl-plus	Zoom in
Ctrl-minus	Zoom out
Alt+Delete	Fill – foreground colour
Ctrl+Delete	Fill – background colour

Acknowledgments

Thanks are due to the following for their help in preparing this book …

Pamela Curtis, Anne O'Donnell, Austin Thomas, Charlie Hothersall-Thomas, Kate Thomas and Dexter.

Also to Epson, Fuji, Nikon and Wacom for allowing the use of their photos.

Index

Bold numbers indicate main entries